BOURNEMOUTH
IN
50
BUILDINGS

PAUL RABBITTS & LIZ GORDON

AMBERLEY

For Katherine and Rebecca: wherever they go, they'll always be Dorset girls

Bournemouth!
How shall I sing thy praise, fair favoured spot,
That nestles 'mid thy hills and silvery groves
Of fragrant pines? From out thy dense alcoves,
Bright villas peep – 't has been my happy lot
To dwell amid thy shady nooks, I wot,
Through many winters

Sir Merton Russell-Cotes

First published 2020

Amberley Publishing, The Hill, Stroud
Gloucestershire GL5 4EP

www.amberley-books.com

ISBN 978 1 4456 9615 7 (print)
ISBN 978 1 4456 9616 4 (ebook)

Typesetting by Aura Technology and Software Services, India.
Printed in Great Britain.

Contents

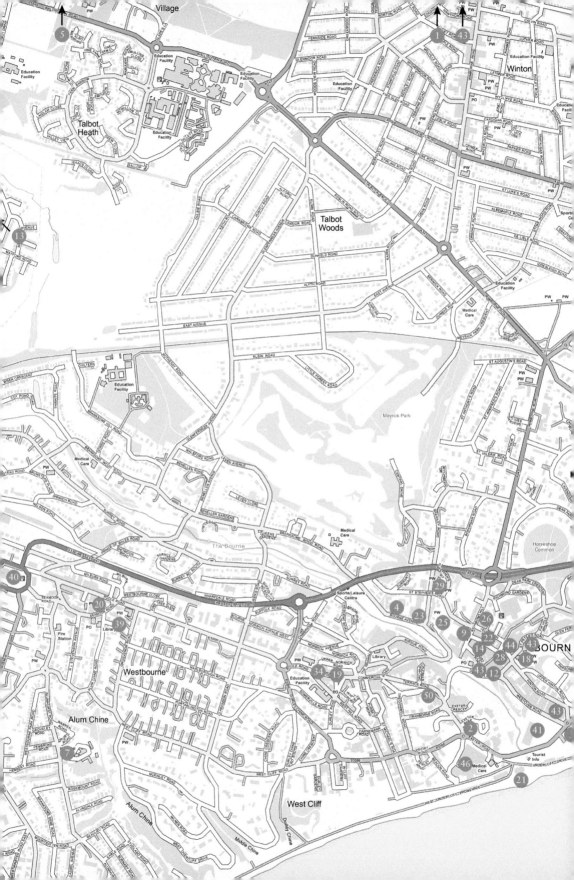

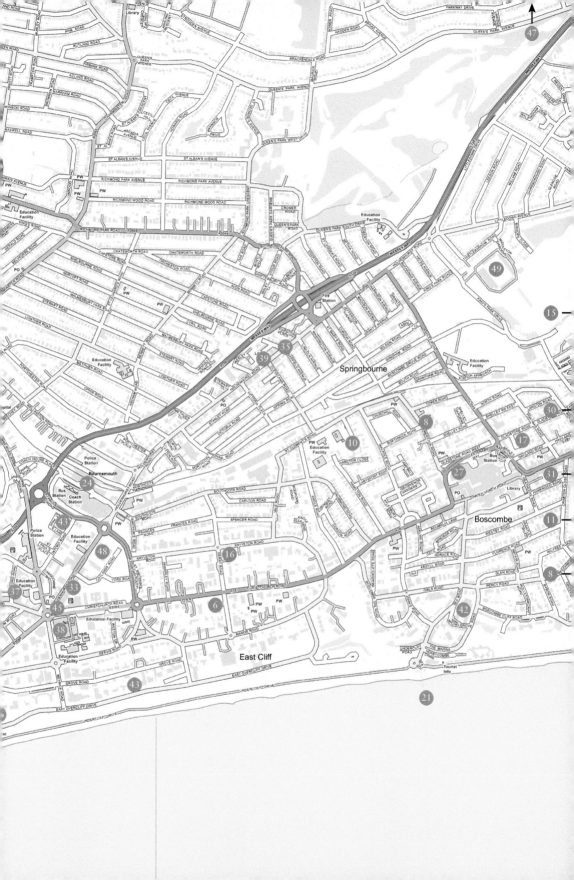

Key

Introduction

Bournemouth is no ordinary seaside town. The shape of the town and its layout is very much reflected by the individual ideas of the early architects who worked here. Buildings were distinctive in style, although many disappeared in the late twentieth century to be replaced by flats and modern office developments. The dominant buildings in Bournemouth in the early years were the churches, water towers and brickworks. As individual estates were sold for housing, different densities and styles marked them from each other and were commemorated in the street names. Although this variety typified the buildings in the older parts of the town, later development tended to be more uniform in style.

However, simply rambling along any of the streets south of the railway station and looking at the upper parts of the buildings reveals a significant variety and individuality of architectural styles and materials. Distinctive buildings include the Bournemouth International Centre, the many hotels and churches that breach the skyline, the college at the Lansdowne, the old Town Hall, the Littledown Centre and commercial buildings in the central town and between the Lansdowne and Central station.

Bournemouth is not, however, an old town. The first buildings in the town began to appear from 1838 onwards. Over the next thirty years local Christchurch architect Benjamin Ferrey laid out the centre of Bournemouth in the form of large villa plots on either side of the lower Bourne valley, initially for the Tapps estate but later working for other landowning clients. After Sir George William Tapps-Gervis died in 1842, the estate was managed by trustees together with the well-known architect and town planner Decimus Burton (1800–81) as their consultant.

In the formation of the townscape of the infant resort, full use was made of dramatic locations on high vantage points near the sea and especially along the clifftop. Thankfully, development was not allowed at the very centre of the valley as, according to Burton, 'The wooded valley through which the Bourne Rivulet flows to the sea is and must always constitute the principal object in the landscape, and therefore any work undertaken there should be most jealously watched and every endeavour made to preserve the natural beauty of the valley...for... the characteristic which distinguishes Bournemouth from most other watering places is its rusticity. This individuality should be maintained and a class of visitor attracted who cannot find the same elsewhere.'

As a consequence, an incredible degree of architectural variety became possible in the town, which is reflected in it today. As retail and commercial premises increased, the many builders and architects working here favoured the late Georgian style. Following the arrival of the railways there was a very rapid increase in the

population – from 5,896 in 1871 to 78,766 in 1911. Within three decades the distinctive visual characteristics of the infant resort were successfully integrated into the most dramatic transformation of its appearance. The peak of building activity occurred between 1880 and 1910. Bournemouth experienced a level of growth almost unmatched in Britain, as road after road of solidly built residential and commercial properties spread remorselessly inland. As consumer demand grew, so did its retail needs. From the turn of the twentieth century, several elegant shopping parades were built, notably Poole Road, Westbourne; along Christchurch Road, either side of Boscombe Arcade; Southbourne Grove; and, to a lesser extent, through Winton and Charminster. One hundred years later and the style of commercial buildings has changed, although sometimes mimicking earlier forms but using modern materials; for example, the JP Morgan building at Littledown and the new offices at the top of Richmond Hill are very different to those further down the hill.

This book is therefore a celebration of the buildings and architecture of Bournemouth. It is not a history of the town, as there are many of these available (refer to the reading list). The buildings and architecture make this the splendid town that it is today and the challenge while doing such a book was getting the list down to fifty, and there will be many who will debate what was not included. However, one building is remembered less fondly in the town. No story about Bournemouth can be told without reference to the ill-fated IMAX building. Built on the site of the old Pier Approach swimming baths, which was demolished in 1986, the IMAX was a controversial addition to the seafront in 1998. Originally mooted with no objections, as soon as locals saw the steel girders going up and realised how tall the building was going to be, the revolt began. The large glass-fronted 'monstrosity' blocked the view coming down Bath Hill across Poole Bay to the Purbecks. Intending to become a prestige leisure attraction with the innovative 3D IMAX cinema, restaurants, bars and a casino, the complex sat unoccupied and was not operational until March 2002. As early as January 2003, due to low visitor numbers, the cinema reduced its opening hours and was shut four days a week, finally closing in April 2005. The other businesses in the complex continued but Bournemouth Borough Council bought the leasehold in 2012 with the intention of lowering the height of the building. No contractors were forthcoming for the work and the decision was made to take the building down and create an open arts space.

In 2005, the IMAX had come first in a Channel 4 poll of 10,000 people for its *Demolition* programme, which asked what building in Britain they would most like to see demolished. And so it was in 2013, at a cost of £7.5 million and much to the delight and relief of residents who welcomed back their uninterrupted view of one of Dorset's most stunning stretches of coastline, the IMAX was demolished.

Thankfully, the buildings celebrated in this book have survived and are incredibly popular with residents and visitors alike to this day, and it is hoped that lessons were learnt from the debacle that was the IMAX.

The 50 Buildings

1. Kinson Community Centre, Pelhams Park

Kinson predates the Domesday Book and was part of the old parish of Great Canford, or Cheneford. Originally, the settlement was known as Cynestan's Tun, and was later recorded in the Domesday Book as Chinestanestone. Its name developed and eventually by 1800 it was known as Kinson. The first building at Pelhams was built around 1788 on land that was part of Manor Farm (previously Kinson Farm). The farm was owned by a well-known local smuggler called Isaac Gulliver.

During the early part of the twentieth century, the house and gardens became used more often by the local community. Children were invited by the owner to gather chestnuts and the Kinson Horticultural Society began to hold annual flower

The Community Centre at Pelhams. (© Howard Noyce)

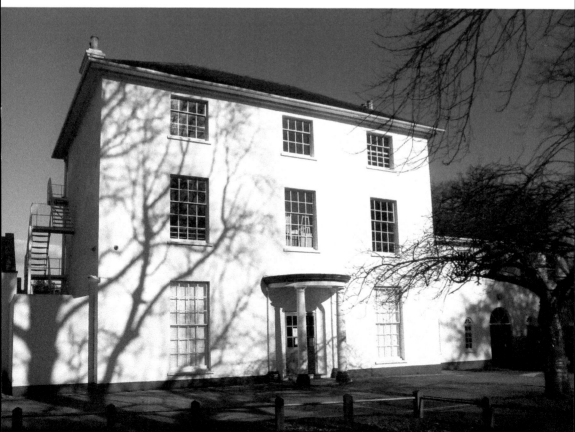

shows from 1907. In 1930, the house and gardens were sold on the condition that the land was used for the benefit of the local people. In the spirit of this, the grounds were used to grow fruits and vegetables while apples were sent to the local hospital.

In the 1930s lots of changes happened. The house was used as a child welfare clinic and a rugby pitch was set up on land at the back of the house. The Kinson Friendly Society (now the Kinson Community Association) started using the grounds to rehearse plays. During the Second World War the house was used as a warden's post and headquarters for the National Fire Service. In 1952, Pelhams became a community centre for the Kinson Social Club and Institute.

During the mid-1950s, the park became the first national accessible meeting place for people in wheelchairs, or 'invalid tricycles' as they were known. A new hall and outdoor tennis courts were built and the bowling green and putting green were opened in 1958. Today the park and community centre take up around 8.5 acres of land and the centre is a Grade II listed building, which remains one of the oldest buildings in Bournemouth.

2. Royal Exeter Hotel, Exeter Road

The Royal Exeter Hotel is a significant and historical landmark in Bournemouth, having originally been built by Captain Lewis Tregonwell in 1812 as his home. Lewis Tregonwell had been an officer in the Dorset Yeomanry who were charged with patrolling the coastline in the area to guard against invasion by Napoleonic France and to combat the smuggling that was common at the time. By 1810, the threat of invasion had passed and Tregonwell had retired and, following the death of their young child, he and his wife Henrietta fell in love with the place and liked the area so much that he built a mansion here for his family. It was later that he added a number of buildings, which he let to visitors who wished to engage in the increasingly popular activity of 'sea bathing' – and so the origins of Bournemouth were laid.

Tregonwell purchased his first 8½ acres of land for approximately £800 in 1810 and had his home built here. Prior to this the site was remote and an odd place to build a house.

It is unlikely that Captain Tregonwell could have envisaged how popular his then home and the seaside resort would become, though there is little doubt that his actions led to countless Victorians being drawn to the region in order to experience what they perceived to be the health-reviving properties of the sea and pine trees.

Today, the original Tregonwell mansion still exists as part of the Royal Exeter Hotel in Exeter Road. By 1820 it was advertised for letting, the first taker being The Marchioness of Exeter in whose honour both the house and surrounding roads were named. The Tregonwells themselves moved into another of their nearby properties. Over the years it has been extended considerably. Large wings were

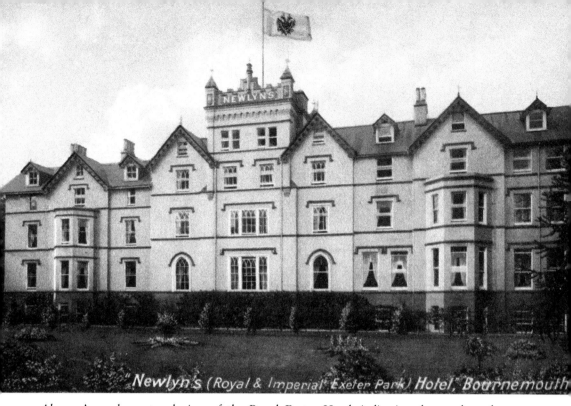

Above: An early postcard view of the Royal Exeter Hotel, indicating the number of changes in name that were often made.

Below: The Royal Exeter Hotel has parts that date back to 1812.

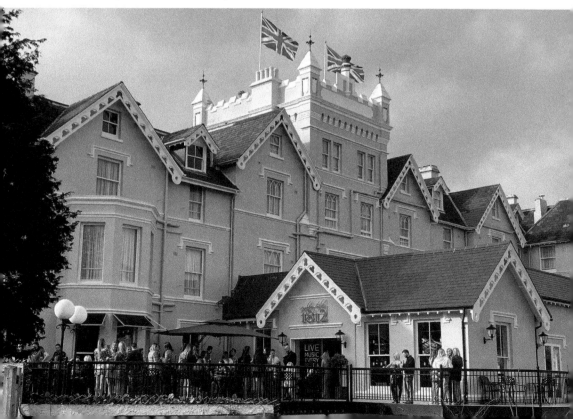

added symmetrically to the south in 1875 and 1886 in the same stucco-Tudor style. The east wing was heightened and extended to the north in around 1900.

A number of significant events have occurred here over many years. While staying here in 1886 the Empress of Austria had no interpreter and, although the empress herself spoke some English, it was more than challenging for her staff to make themselves understood. A cow was kept in the priory stables opposite the hotel and milk was taken for her majesty, under the supervision of her own doctor. She was also very fond of hot seawater baths, and the water for these was supplied from the seawater baths of Messrs Roberts & Co., situated near the pier. Her attendants had difficulty in explaining whether milk or water was required, so the gardener was labelled with miniature sandwich boards; the one on his back said 'cow' and the one on his chest said 'sea-water'. He wore these during the day and when water was required he was poked in the chest, and if milk was needed he was slapped on the back.

3. The Royal Bath Hotel and Westover Villas, Bath Road

To many, the Royal Bath Hotel *is* Bournemouth. It has been one of the most important buildings throughout the history of the town, being the very first hotel opened here. In 1835, after the death of Sir George Ivison Tapps, his son, Sir George William Tapps-Gervis, inherited his father's estate and began developing what was a seaside village into a resort to match those that had already grown up along the coast at Brighton and Weymouth. Sir George employed architect Benjamin Ferrey from nearby Christchurch to plan the Gervis estate. This included the Westover Villas, which began in 1837. In his design Ferrey was to include two hotels, the first being the Bath Hotel and the other the Belle Vue Boarding House, which stood where the Pavilion is now located. The Westover Villas were built for families to hire during the summer and fronted on to the newly laid Westover Gardens. The Royal Bath Hotel opened as the Bath Hotel on Queen Victoria's coronation day in 1838.

Bought eventually by Merton Russell-Cotes and extended between 1878 and 1880 by town surveyor Christopher Crabbe Creeke, it was reopened in August 1880. It had also become known as the Royal Bath Hotel after the Prince of Wales stayed here in 1856. Creeke added a second floor to centre, with Corinthian columns, projecting corner pavilions with canted bays, and recessed chateau roofs of patterned slate with iron cresting. Its three spired tourelles, with patterned slates and moulded corbel bases, are very distinct.

For many years it was the hotel of choice for VIPs. Former doorman Ron Hands remembered how jeans were forbidden in the restaurant – even for pop stars. He said: 'I turned Sting away when he came in with his wife. I said, 'You can try but they don't let you in there.' He came back and said, 'You were right, Ron. We're going down the pier for a burger.'

Taken from the *Bournemouth Tourism Guide* of 1965.

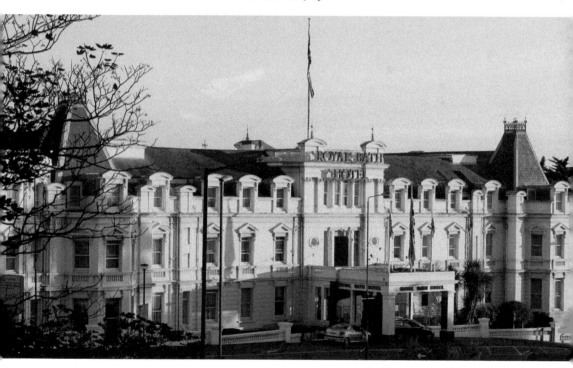

The magnificent frontage of the Royal Bath Hotel.

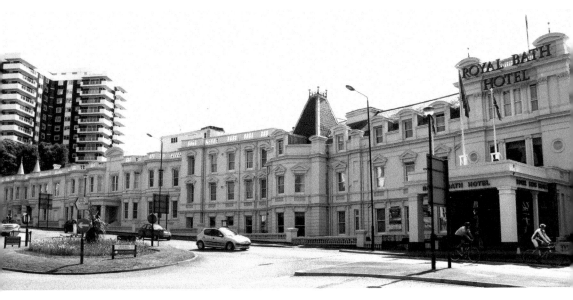

Above: The Royal Bath
Hotel, with no sea
view on this elevation.
(© Alwyn Ladell)

Left: The Royal Bath Hotel
and its distinctive tourelles.

4. The Former Royal National Sanatorium Hospital, Bourne Avenue

In 1850, the Medical Committee of the Royal Brompton Hospital in London decided to build a small sanatorium in Bournemouth, to be financially independent and to 'receive those cases where convalescence has been established'. It was specially built in 1855, at the cost of around £15,000, to designs by the architect E. B. Lamb. The Royal National Sanatorium for Diseases of the Chest opened its doors on 2 October of that year. It was extended in similar style by Christopher Crabbe Creeke in 1863 with further, more distinct, extensions by Sir Arthur W. Blomfield to the west in 1873 and H. E. Hawker and Mitchell in 1904. A magnificent building, it was eventually Grade II listed and is described as a 'powerful style typical of Lamb, rustic Italianate with echoes of Vanbrugh'.

Although more of a convalescent home rather than a sanatorium, as the word was understood later, it was the first of any such establishment anywhere in the world. It contained ninety-seven beds for consumptive patients and for those suffering other chest diseases. It was almost entirely supported by voluntary contributions. In 1948, the Bournemouth and Poole Sanatoria Hospital Management Committee took over control. In 1958, the Bournemouth and Poole Sanatoria Hospital Management Committee amalgamated with the Bournemouth and East Dorset Hospital Committee. By then the hospital was known as the Royal National. It became an NHS hospital in 1974 but, when treatment was gradually moved elsewhere, it closed its doors in the late 1980s.

The Royal National Sanatorium and the south frontage, designed by architect E. B. Lamb.

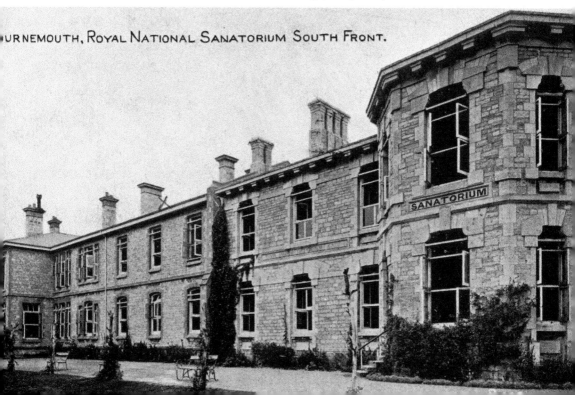

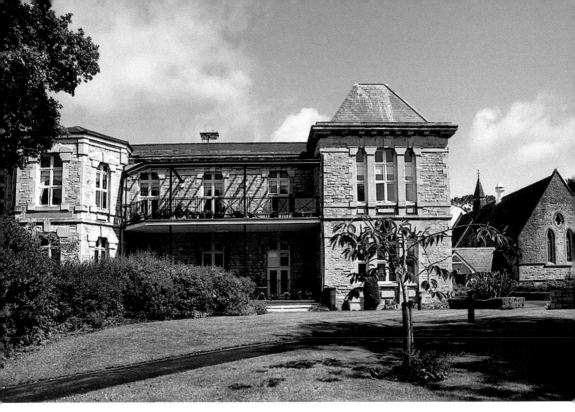

Now award-winning retirement homes after restoration.

Between 1999 and 2001, Bovis Retirement Homes converted the hospital to residential use resulting in a commendation for Best Retirement Development in the National Homebuilder Design Awards 2002, plus a Bournemouth Civic Trust Award in 2003.

5. Talbot Village

On the boundary of Bournemouth and Poole is located Talbot Village. The old part of the village was built between 1850 and 1862 because of the philanthropy of two sisters: Georgina and Mary Talbot. Georgina and Mary split their year between their home in Surrey and Hinton Wood House on the East Cliff of Bournemouth with their family, and it was while living in Bournemouth that the sisters discovered the many poor who were suffering and struggling in the region. They bought 465 acres of land from Sir George Tapps-Gervis to create a self-sufficient village to enable unemployed workers to support themselves and their families by their own efforts.

Between both sisters they employed the poor to clear the land to build new cottages, which were completed between 1850 and 1862. The workers were allowed to stay in the cottages and eventually Talbot Village began to develop. The original cottages were built on a 1-acre plot and each had a well, animal pens and fruit trees. The residents were charged a rent of between 4 and 5 shillings per week. Georgina Talbot then had seven almshouses built for the elderly and widowed.

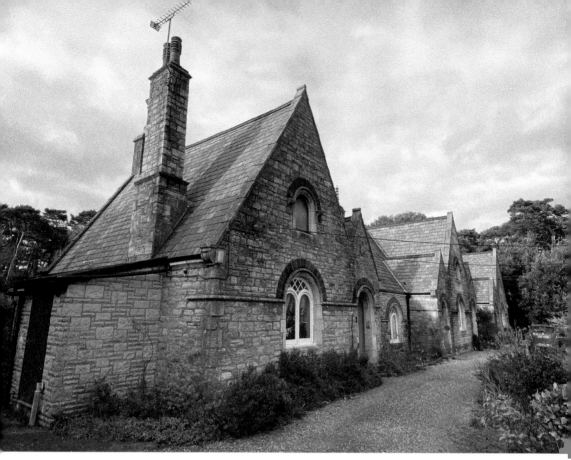

Above: Talbot Village almshouses.

Below: Talbot Village School, built in 1862.

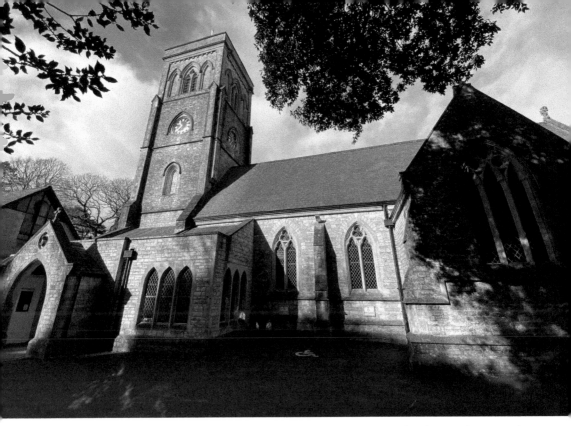

St Mark's Church, Talbot Village, protected by a conservation order that is administered by the Talbot Village Trust, along with many other buildings here.

The school was built for the village in 1862 and held sixty-eight children. It has since been extended over the years, and in 1992 an extension increased the school's capacity to 460 children. The Talbot sisters received no financial return from their residents for having set up the village. Georgina Talbot was motivated by the death of her elder brother and her father. She used the money to help the poor of Bournemouth and Kinson because she simply cared about the area. In addition to the cottages, the village had six farms, each covering around 20 acres, to create employment and trade for the village. Three of the farm buildings survive: Highmoor Farm is still operational, White Farm served as stables into the early years of the twenty-first century, and Lollipop Farm has been converted into a dwelling house.

6. Bournemouth Natural Science Society, Christchurch Road

Bournemouth Natural Science Society's headquarters is at No. 39 Christchurch Road and is a Grade II listed building that provides the venue for the society's lectures and meetings today. It was built in 1865 and was originally a villa called 'Bassendean'. It houses a museum and library and stands in a botanical garden with many interesting specimens. The building is a mixture of styles, which was common in Victorian architecture at the time.

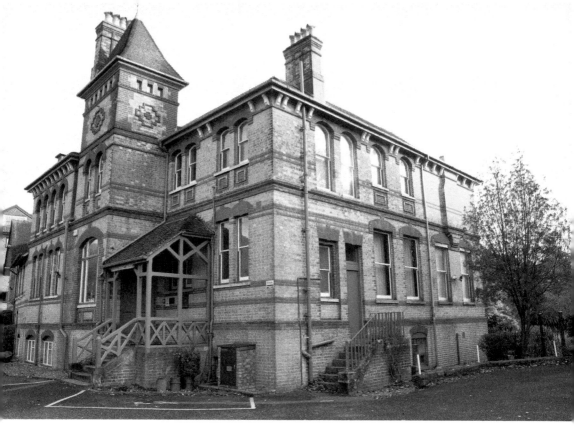

Built in 1865, this was originally a villa called 'Bassendean' before it became the home of Bournemouth Natural Science Society. (© Alwyn Ladell)

The Bournemouth Natural Science Society (BNSS) was formed in 1903 with the aim of promoting the study of all branches of science and natural history. For more than a hundred years the society has educated and inspired both its members and the general public.

7. Former Herbert Hospital, Alumhurst Road

The former Herbert Hospital and associated lodge are now both Grade II listed buildings and are situated at No. 49 Alumhurst Road, Westbourne. It was largely based on designs by Florence Nightingale and was built as the Herbert Memorial Convalescent Home between 1865 and 1867 by T. H. Wyatt in memory of the late Lord Herbert of Lea. Sidney, 1st Baron Lord of Lea, was born in 1810. He was the second son of George Augustus, 11th Earl of Pembroke, and was educated at Harrow and Oriel College, Oxford. From 1832, he was the Conservative MP for South Wiltshire, until his peerage in 1860. An eminent politician and statesman, he was secretary to the Board of Control (1834–35), secretary to the Admiralty (1841–45), War Secretary under Peel (1845–46), Aberdeen (1852–55, during the Crimean War), and Palmerston (1859–60). He led the movement in favour of medical reform in the army and was primarily

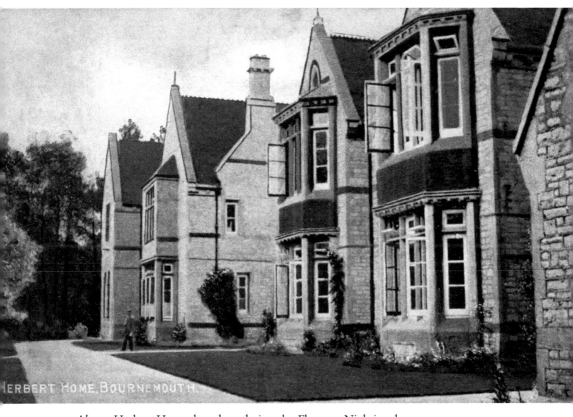

Above: Herbert Home, based on designs by Florence Nightingale.

Below: Herbert Memorial Convalescent Home.

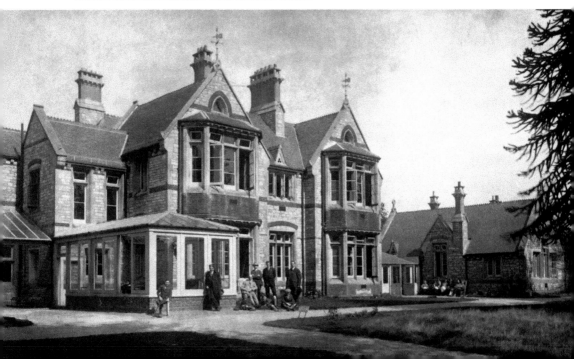

The former Herbert Memorial Convalescent Home today.

responsible for Florence Nightingale going to the Crimea. He was married to Elizabeth, daughter of Lieutenant General Charles Ashe à Court-Repingham in 1846. They had seven children including George, 13th Earl, and Sidney, 14th Earl of Pembroke. He died on 2 August 1861. During his time, he was president of the Salisbury Infirmary.

Herbert Hospital stands in 4 acres of the Alum Chine estate. The foundation stone was laid by the Earl of Pembroke in 1865. Initially, it was mainly a convalescent hospital for patients discharged from the Salisbury Infirmary, who were 'likely to derive from the mild climate and sea air of Bournemouth'. Fifteen of the sixty beds appear to have been allocated for this purpose, with the remainder being available for patients recommended by 'subscribers'. From October 1914 to June 1915, the hospital was used exclusively for Belgians.

By 1947 it had been renamed the Herbert Sanatorium and was run by Bournemouth Borough Council. In 1948 the Bournemouth and Poole Sanatoria Hospital Management Committee took over control. It later became part of the Dorset NHS Trust and is known locally as 'Herbert Hospital'.

8. Palmerston Road Water Tower, Boscombe, and Seafield Gardens Water Tower, Southbourne

The Palmerston Road water tower, holding 160,000 gallons, was built in 1869 for the Bournemouth and District Water Company (later Bournemouth Gas & Water Company) to improve the water supply to Springbourne and Boscombe – at that time there were only 244 houses in Boscombe. A Grade II listed building, the 1976 description says: 'Massive tower of round-arched brickwork, in alternating courses of reddish-brown stretchers and blue headers. Round-arched entrance. 3 main storeys: round-headed in triplets on ground and first floors, in quartets on second - all blind to north and south. Double dentil cornices above ground and first floors, triple dentil main cornice with far-projecting top. Tank on roof.'

In 1996, permission was granted to convert the then disused water tower into eight flats with a ground floor storage area. This included the removal of the water tank on the roof, and it was replaced by the double pitched roof and parapet in 1997.

Below left: Palmerston Road Water Tower – now flats. (© Alwyn Ladell)

Below right: Seafield Gardens Water Tower. (© Alwyn Ladell)

In Seafield Gardens a water tower was originally built in 1898 to supply the Southbourne-on-Sea area following problems with the Iford Pumping Station. Built at a cost of £2,500 for West Hants Water Company, the tower is now a listed building in private ownership.

9. Norfolk Royale Hotel, Richmond Hill

The Norfolk Royale Hotel has an extraordinary history as one of Bournemouth's most iconic buildings. In 1870, two large villas on Richmond Hill in Bournemouth, built by the town's founders Sir George Ivison Tapps and his son Sir George William Tapps-Gervis, were amalgamated to make the Stewarts Hotel. It was during the nineteenth century that the Stewarts Hotel became a firm favourite with Henry Fitzalan-Howard (1847–1917), 15th Duke of Norfolk, and eventually became first choice for the duke and duchess's summer retreat. Why the Duke and Duchess of Norfolk chose the Stewarts Hotel as a retreat above other Bournemouth hotels is a mystery, but the most likely explanation is the hotel's location – right opposite the Roman Catholic Sacred Heart Church. Henry Fitzalan-Howard was a major supporter of the Catholic Church in the years following Catholic emancipation, and founded the Catholic cathedrals at Arundel and Norwich. He was also a significant contributor to funds for the building of Westminster Cathedral. Surprisingly, the only record of the duke and duchess visiting appears in the 1883 *Bournemouth Guardian and Visitors Guide*

The Norfolk Hotel – an early Edwardian view.

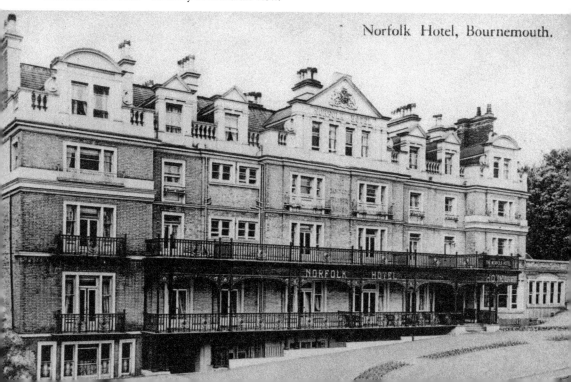

Norfolk Hotel, Bournemouth.

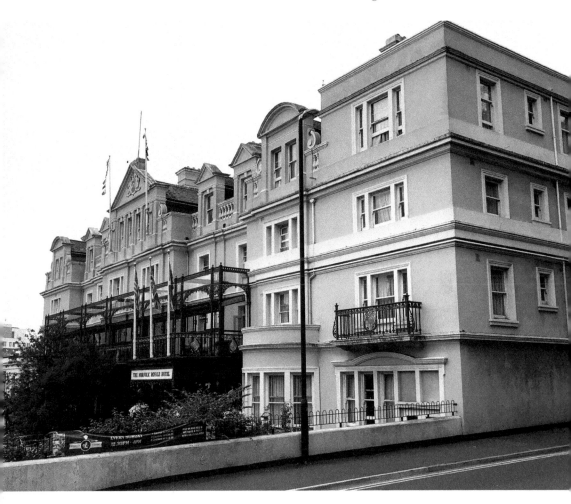

Above: The Norfolk Royale Hotel.

Left: Scottish ironwork from the famous Glasgow Saracen Foundry of Walter Macfarlane & Co.

under the heading of 'Fashionable Visitors' where the publication announced that, 'The Duke and Duchess of Norfolk are staying at Stewarts Hotel'.

It was in honour of its regular VIP guests, and in tribute to the major role that the dukes of Norfolk had played in English life over the years, that the Stewarts Hotel changed its name to The Norfolk Hotel in 1910 and adding 'Royale' in 1988. In 1974, the Norfolk Royale Hotel qualified for listed building status, primarily because of the art nouveau veranda, which was added to the front of the hotel in 1903 and includes large amounts of Scottish ironwork from the famous Glasgow Saracen Foundry of Walter Macfarlane & Co.

10. House of Bethany, St Clement's Gardens, Boscombe

The Society of the Sisters of Bethany built a convent, designed by Richard Norman Shaw, close to St Clement's Church in 1872. From then until 1939 they ran an orphanage for 100 children, many of whom stayed on with the nuns. A school of embroidery was opened, with assistance from Sir Ninian Comper,

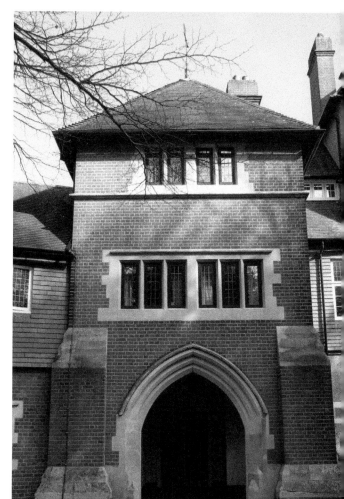

The former Society of the Sisters of Bethany, who built a convent that was designed by Richard Norman Shaw.

The chapel in the gardens of the House of Bethany. (© Alwyn Ladell)

and the baking of altar breads began in 1873. In 1940, the House of Bethany at Bournemouth received a direct hit from a German bomber as a result of which two sisters died. Extensive damage was done to the orphanage, which by then was being run down and converted into St Gabriel's Convalescent Home for Children. St Gabriel's was altered and reopened to receive elderly ladies in 1955. The order had opened houses in Winchester, Hindhead and Southsea and, in 1986, they sold the House of Bethany in Boscombe to Bournemouth Council. The council used part as offices, converted it into sheltered accommodation and demolished the rest to build housing. The order has now consolidated at their new mother house in Southsea. The 1976 listing describes the Bethany complex thus: '1874–5, enlarged 1880, one of R Norman Shaw's boldest works, built largely of concrete with W. H. Lascelles as contractor.'

11. Shelley Theatre, Beechwood Avenue

The Shelley family connection with Bournemouth is well known – St Peter's Church is where Mary Shelley, author of *Frankenstein*, is buried with the heart of her husband Sir Percy Bysshe Shelley. In fact, their influence is apparent in road names in the area surrounding Shelley Manor: Shelley, Florence, Wollstonecraft and Percy; and also their contemporaries: Byron, Robert Louis Stevenson and Irving.

Their son, Sir Percy Florence, born in November 1819, bought Boscombe Cottage for his mother and renamed it Boscombe Manor. Sadly, his mother died before it was completed, so Percy and his wife Jane moved in. Sir Percy loved the theatre and had a timber version built in the grounds of Boscombe Manor. It was replaced in 1870 by a much bigger theatre, which exists today. According to the Shelley Theatre website: 'Lady Jane was often too ill to go downstairs but she could watch the shows from her bedroom through a shutter which is still there today. The bedroom is now used as our projection booth!'

The manor house has seen many changes of use throughout the years: it was bought by Grovely Girls' School in 1911, who renamed it Grovely Manor, before being sold to the council in 1938 as a Home Guard and first aid centre.

After the war it was taken over by Bournemouth Art and Technical College. In 2005, the council auctioned it to Charles Higgins Ltd, who saved the building from being demolished. Part of the building is now a medical centre. A group of volunteers formed the Shelley Theatre Trust, who leased the other part and embarked on a large restoration project creating additional performance spaces plus conference and meeting rooms. The theatre is furnished with 220 seats reclaimed from the ill-fated IMAX cinema.

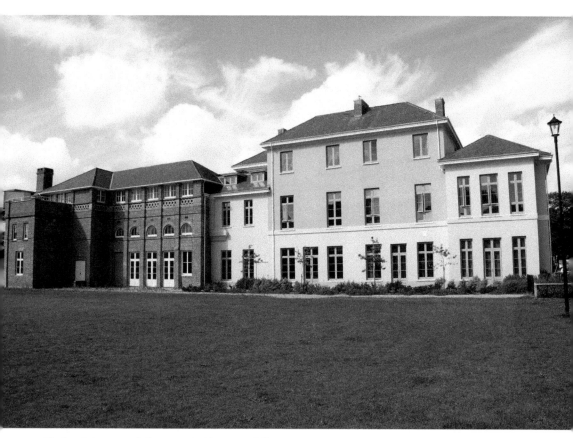

Shelley Manor and theatre. (© Alwyn Ladell)

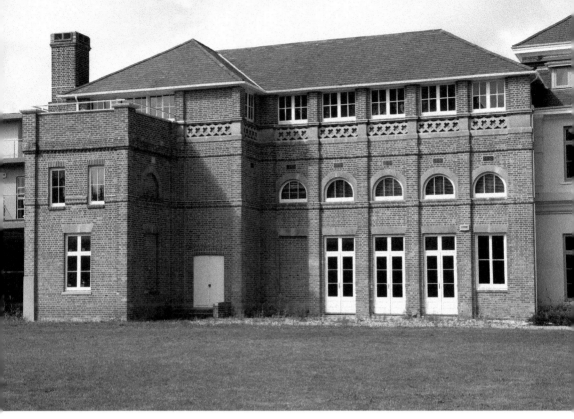

Shelley Manor Theatre. (© Alwyn Ladell)

12. Gervis Place, Including Gervis Hall and Bournemouth Arcade

A number of fine buildings exist in this locality, including Gervis Hall and Bournemouth Arcade. Gervis Hall is described as an 'asymmetrical Italianate stucco commercial building, circa 1860, on bend in road, 3 storeys and dormers. Entrance bay has doorway flanker by rusticated pilasters, rusticated quoins to 2 upper floors, pedimented let floor window. Canted bay on left to 1st and 2nd floors, with thin rusticated pilaster beyond. Straight front, 3 windows wide, to right. Blind casings to all windows...The former Dingles store, now House of Fraser, Anderson and McAuley (William Hill), Gervis Hall (Hornes/Steamer Trading) and The Arcade (Nos 1 to 23A (consec)) and No 28 Old Christchurch Road form a group'.

The Arcade commenced in 1866 and took seven years to complete. The two sides and the four 'pepper castors' were erected some time before the roof was put on. Owing to the difficulty of erection, mainly due to the great depth and unsatisfactory nature of the foundation, the project threatened to ruin the builder. He lived to see the day, however, when his former 'folly' became one of the town's most valuable assets. It is interesting to relate that so little was thought of the value of the premises that, in 1868, a shop and residence could be had for £40 per annum. Today Arcade shops are assessed significantly higher!

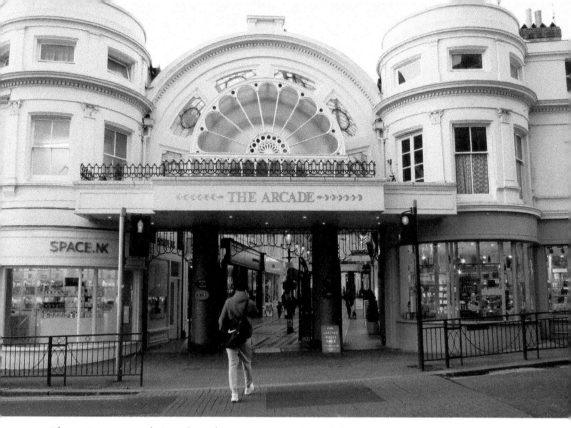

Above: Bournemouth Arcade and its stunning variety of shops.

Below: Gervis Hall. (© Alwyn Ladell)

13. St Clement's Church and the Knole (Freemasons Hall)

St Clement's Church is one of Bournemouth's finest buildings and is worthy of its Grade I listing. It was the first parish church to be built in Springbourne in an area which was mainly surrounded by woods and moorland. The church owes its inception to the foresight and wisdom of three individuals, including Revd Mordern Bennett, the first vicar of St Peter's (Bournemouth's mother church), who was responsible for the selection of eight new sites for churches in the town, including St Clement's. By public subscription, in 1867 he was able to have enough funding to buy the land off Mr Sloman, who owned the land to the south of Springbourne. Here Bennett built a church, a vicarage and a school for boys and schools. Originally, the parish of St Clement's was part of the parish of St Peter's. Before the new church was built Bennett hired some cottages in Holdenhurst Road as a temporary church, with the first service held on 10 November 1867. It was through the generosity of Edmund Christy, who originally came from Aberdeen and who bequeathed a gift of £30,000 for the building of the church, vicarage and schools. On 19 August 1871, the parish of St Clement's was eventually formed. The architect for the new church was

St Clement's Church, one of architect John Sedding's most impressive buildings.

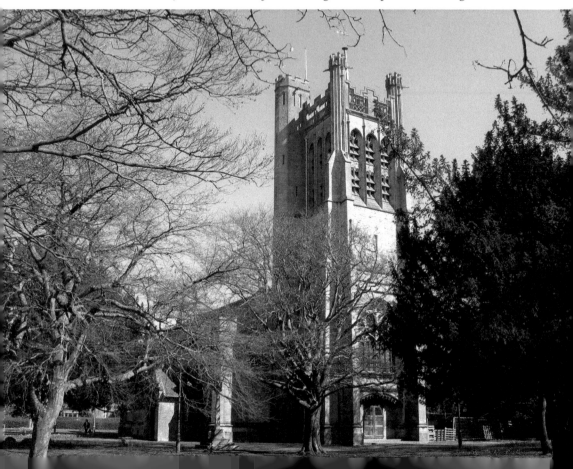

John D. Sedding, a talented Bristol architect who was responsible for the Tudor-style home that Christy lived in nearby – the Knole. The subsequent Gothic design of St Clement's Church was entirely down to Sedding, a man whose name has often been described 'as great in the history of English Architecture as Rosetti in English painting'.

The foundation stone to the church was laid by Morden Bennett on St Clement's Day, 23 November 1871, with the church consecrated by Bishop Wilberforce of Winchester on 15 April 1873. The tower was added in 1890–03 after Sedding's death, and further redesigned above first-floor level by Henry Wilson.

The Knole, which is now the Freemasons Hall, had as its first owner, Edmund Christy of the hat and towel family and who commissioned Seddon to design this wonderful building. For his own house at the Knole, no expense was spared in the design or decoration. Edmund Christy left Bournemouth around 1880 and died in 1902 at Adcote in Shropshire aged seventy-five.

Following the departure of Edmund Christy, the house was leased to a number of distinguished people until it was sold to a Mrs Richard Page Croft, who bequeathed it to her son, Sir Henry Page Croft, the first MP for Bournemouth from 1910. In the Second World War, he served as Undersecretary of State for War between 1940 and 1945 and was elevated to the peerage in 1940 when he became 1st Baron Croft of Bournemouth. He died in 1947 and is buried at Croft Castle in Shropshire.

The Knole, now the Freemasons Hall. (© Alwyn Ladell)

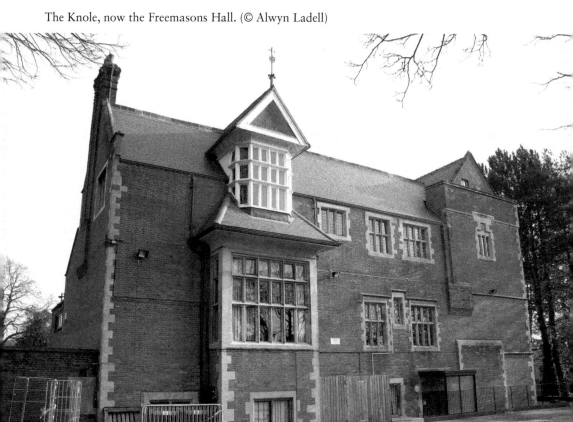

During the Second World War, the Knole was used as a Red Cross nursery for young children evacuated from Portsmouth and London. With the death of Lord Croft, the Knole was sold and much of the 5 ½ acres of garden was developed with housing, while the house itself became the Knole Private Hotel until it was sold to the Freemasons of Bournemouth in 1957.

14. Church of the Sacred Heart, Albert Road

This important building, designed by the architect Henry Clutton, was opened on 5 February 1875. The architecture presented a mixture of neo-Gothic and neo-Norman influences and reflected the spirit of the Victorian era. It was to be another 100 years before the church was consecrated by Bishop Worlock, following a reordering of the interior. The diocese of Portsmouth was established in 1882 and, during the 1880s, a new chancel and transepts were added to meet the growing needs of the Catholic population. At the same time a house was built for the Jesuits who served the area. On 31 December 1900, the newly enlarged oratory was blessed.

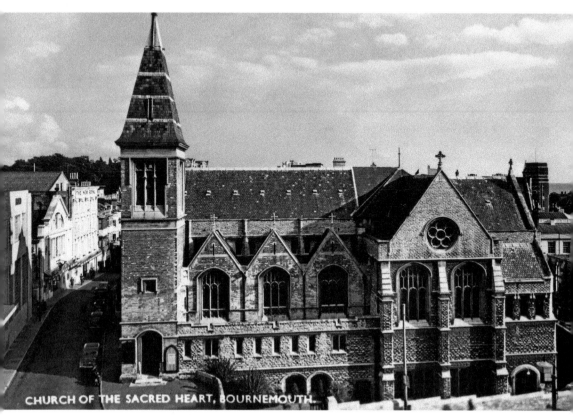

Church of the Sacred Heart, dating from 1875.

The Sacred Heart is the mother church of some seven local Roman Catholic churches and Mass centres built to serve the needs of a rapidly growing population. During the Second World War, the church was fortunate to escape relatively undamaged in the bombing which destroyed the Methodist church a few yards further down Richmond Hill. In 1969, the Jesuit community handed over the pastoral care of the Sacred Heart parish to the secular priests of the diocese of Portsmouth.

The 1970s and 1980s saw considerable works of restoration to both the church and the presbytery. During this time, the interior of the church was reordered in line with the liturgical decrees of the Second Vatican Council. It was during this time too, and to mark the historic visit to England and Wales by His Holiness Pope John Paul II, that the belfry was restored and a ring of six bells was installed. On the evening of Monday 28 November 1983, the bells of Richmond Hill rang out for the first time. The Sacred Heart Church is one of only a few Catholic churches in this country to have its own ring of bells.

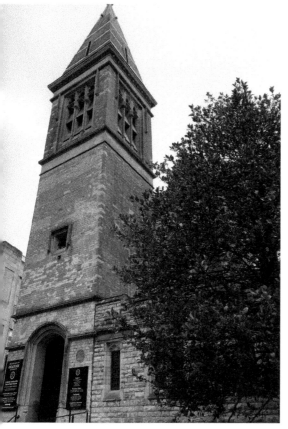

Above left: Church of the Sacred Heart and its prominent tower.

Above right: Church of the Sacred Heart, even on a cloudy day, looks magnificent.

15. Pumping Station at the Old Waterworks, Iford Lane

The waterworks were built in 1875 to pump water to the water tower at Seafield Gardens, which supplied Southbourne properties with mains water. By the late 1890s it was no longer used and was taken over by a community of exiled Russians headed by Count Vladimir Tchertkov, whose wealthy mother had a holiday home called Slavanka nearby.

A large detached property called Tuckton House in Saxonbury Road was purchased by the count for himself and members of the commune to live in while they set up a printing press at the disused waterworks to print the works of Leo Tolstoy, which were banned in Russia at that time. The former waterworks were converted into residential properties, with some new homes also built on the site in the 1990s. A blue plaque dedicated to the former Russian inhabitants adorns the building.

Slavanka became a hotel and conference centre in the 1920s and was demolished to be replaced by a large Sunrise Senior Living 'flats for the elderly' complex at No. 42 Belle Vue Road in 2007. Tuckton House has since been demolished.

The former pumping station on Iford Lane, with Russian connections.

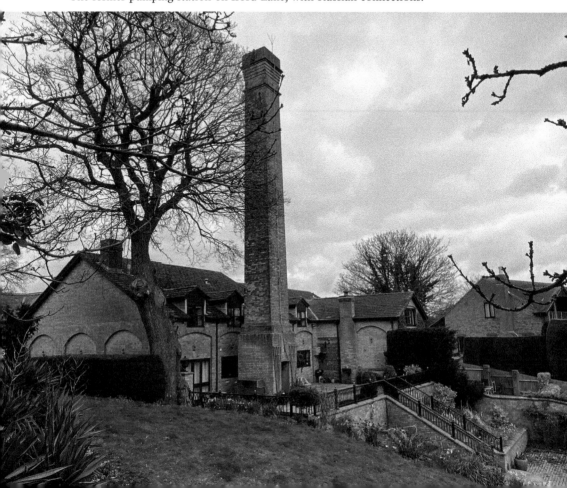

16. Langtry Manor Hotel

The history of the Langtry Manor Hotel has courted controversy for a number of years with its supposed connection with Lillie Langtry and Edward VII. Emilie Charlotte le Breton (1853–1929) was born in Jersey and became known as Lille Langtry due to her enormous popularity and acceptance as a 'professional beauty', primarily as a result of sketches and reproductions made of her by artist Frank Miles. Due to her popularity she became known by the Prince of Wales, who later became Edward VII, eventually becoming one of his many mistresses.

It is commonly thought that in order to meet without disturbance she was to eventually live for several years in Bournemouth at the Red House on the East Cliff, which the prince had built especially for her. This large, red-brick, red-tiled house, the upper part of which is Tudor in style with black beams, became known as The Red House. This house in Derby Road is now the Langtry Manor Hotel and a popular Bournemouth restaurant, originally known for many years as the Manor Heath Hotel. Thought to have been built in 1877 by the Prince of Wales, the house is unique in Bournemouth. Allegedly designed by Lillie herself and executed in the style of a Victorian country house, it retains many of its original features – balconied bedrooms, carved fireplaces, mullioned windows and elegant staircases.

The Langtry Manor Hotel. Its origins are open to debate to this day.

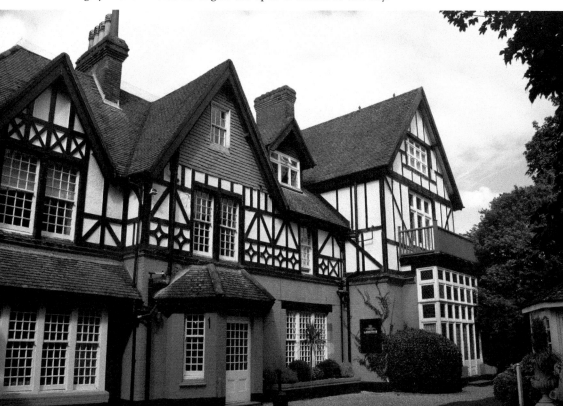

In the hotel today are portraits of Edward and Lily, who became known as the 'Jersey Lily', and features a very small hatch high on a wall in the dining room from where the future king would apparently inspect his guests before joining them for dinner. Also, embossed into the dining room fireplace are the initials 'ELL'. Lillie died at Villa de Lys in Monaco in February 1929 at the age of seventy-two.

However, other conflicting stories do circulate. The 'ELL' initials possibly relate to Emily Langton Langton, latterly known as Emily Langton Massingberd, widowed women's rights campaigner and temperance activist (1847–97) and it was after her death that the house was sold. In 1938, a new set of owners converted it into a hotel, the 'Manor Heath Hotel', which advertised it as having been built originally for Lillie Langtry. However, despite the hotel's claims, no actual association between Langtry and the house seems to have ever existed, but the story persists and is now a local legend. By the 1940s, when memories of Emily Langton Langton's activities at Bournemouth had become more distant, the hotel proprietors seem to have muddled the names and began to say that the single lady who had lived at the Red House was none other than Lillie Langtry. Either way, it is a remarkable building today.

17. The Old School House and Former Boscombe British and Foreign School

Now a coworking space for small creative businesses, the Old School House in Gladstone Mews, Boscombe, was originally built in the neo-Gothic style as the Boscombe British and Foreign School. The earliest part of the building dates back to 1878, when the foundation stone was laid by Sir Percy Florence Shelley, Frederick Moser and others on 21 August. Sir Percy Florence Shelley of Boscombe Manor was the son of poet Percy Bysshe Shelley and Mary Wollstonecraft Shelley, author of the Gothic novel *Frankenstein*.

The British and Foreign School Society (BFSS) was formed to carry on the work of a young Quaker named Joseph Lancaster, who founded his first school in Southwark in 1798 to provide education for 'the industrious classes'. Joseph Lancaster introduced a system of 'mutual and self-instruction', which included rewards as well as punishment and a non-denominational approach to religious education. When the Education Census of 1851 was taken, there were 514 BFSS schools in the UK, and the movement also spread overseas.

The Education Act of 1879 established a new system of locally funded boards to build and manage schools. There were objections to the local rates being proposed and, in Boscombe as well as elsewhere, schools fought to keep their autonomy for as long as possible by seeking voluntary contributions. Eventually, however, the resources of the BFSS were diverted to teacher training and the building of teacher training colleges, with the schools themselves being absorbed into the new system. In 1876, a royal commission recommended that education be made compulsory

to put a stop to the use of child labour. However, it took many more years for full school attendance to come about, even though it was made compulsory for five to ten year olds in 1880.

The British and Foreign School at Boscombe was, therefore, built at a time when a great deal of energy was being devoted to improving both educational provision and the lot of children generally. Boscombe was growing rapidly during this period and the school attached to the Church of St Clement's was oversubscribed. The new British and Foreign School in Gladstone Road was opened in 1879 and it consisted of two rooms, the larger one to the south being for older children.

An enthusiastic supporter of the school was Alderman Henry Curtis Stockley of 'Essendene, Christchurch Road, Boscombe', who was school treasurer. In June 1895, an appeal was made in the press for funds to provide extra accommodation and the school was extended to the south a number of times between 1895 and 1903, when it became a council school. The building continued to be used as a school until the 1960s, after which it became a children's theatre and, in the 1990s, it was used for adult education.

The former Boscombe British and Foreign School.

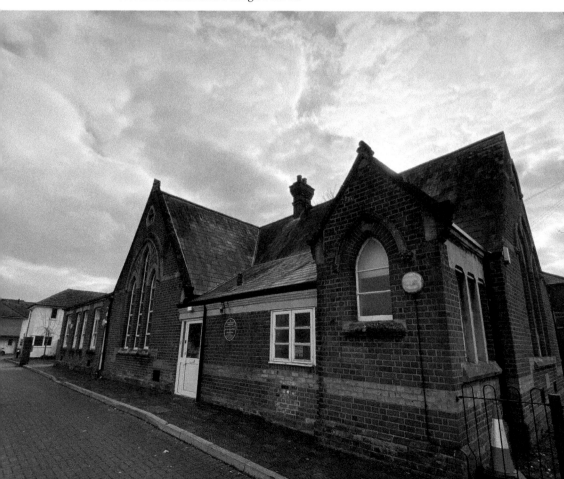

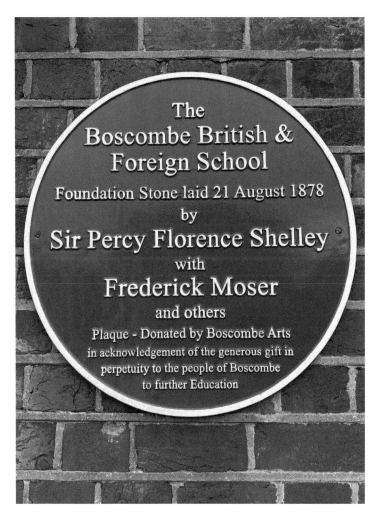

The former
Boscombe
British and
Foreign School
plaque.

18. St Peter's Church, Hinton Road

Sitting magnificently in the heart of the town centre, St Peter's is the mother church of Bournemouth. This impressive Grade I listed building is in Gothic style and contains many fine examples of stained-glass windows and frescoes together with a 202-foot spire. The chancel has been described as 'one of the richest Gothic Revival interiors in England'.

It is best known outside of the town for being the burial place of Mary Shelley, author of *Frankenstein*, in the Shelley family vault, which also bizarrely contains the heart of her husband, the poet Percy Bysshe Shelley. Sir Hubert Parry, composer of the anthemic hymn 'Jerusalem', who was born on Richmond Hill and for whom there is a blue plaque erected at the site, was baptised in the church.

Completed in 1879 after taking twenty-four years to build, this Church of England church in the diocese of Winchester was designed by architect G. E. Street on the site of two semi-detached cottages that were being used as temporary places of worship. Street went on to design the Royal Courts of Justice in London.

The Chapel of Resurrection in the grounds, built in Italianate style and is distinctly different from the church, contains the names of twenty-four fallen young men from the 7th Battalion Hampshire Regiment whose colours fly in the churchyard. The church was awarded Heritage Lottery funding in 2017 to develop a community project telling their story.

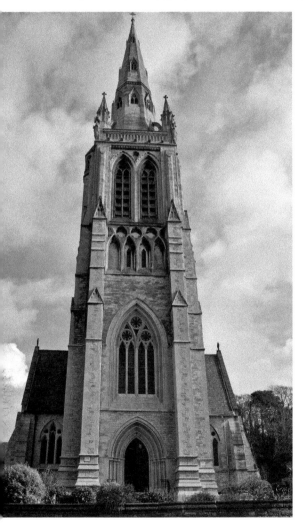

Above left: St Peter's Church, designed by famous architect G. E. Street.

Above right: Built in the Gothic style and worthy of its Grade I listing.

The Chapel of Resurrection in the grounds.

19. Former Bournemouth School of Art, Poole Hill

This fine building on Poole Hill was built in the 1880s as the Municipal School of Art, occupying the upper floors, which later became well known as Bumbles Night Club and is now Canvas nightclub. The ground floor and cellars were occupied by Bayley & Sons, ironmongers and electrical engineers (1880s–1950s); John Blundell Ltd, credit drapers (1960s); H. P. Arnett & Son, motor agents (1970s); Lexterten reproduction furniture (*c.* 1980s/90s); Westcliff Motors (to *c.* 2001); and were then boarded up for around fifteen years. In 2017, Jennifer Tingay of Southbourne Ales fame won approval to open a crowdfunded microbrewery – Poole Hill Brewery.

One of the more notable occupiers were Bayley & Sons, ironmongers and electrical engineers (1880s–1950s). John Charles Bayley (1845–1935) was born in Poole and lived with his wife Barbara and family here at Dene House (with the art college above), Poole Road. He was assisted in the business by two sons, Henry and Frank, and the oldest of his three daughters, Margaret, who was the

Built in the 1880s as the Municipal School of Art, the building has had a diverse range of uses over many decades.

bookkeeper. He pioneered the electrification of many properties on the West Cliff and was responsible for telegraphic communication locally. His youngest daughter, who became a schoolteacher, was named Dora Electricia Bayley.

Its more recent history has been as a well-known nightspot. Charlie Downton, manager of local group The Sandstorms, and a business partner launched the 45 Club at No. 45 Poole Hill in the Triangle on 30 October 1964 with an appearance by The Initials Beat Combo and The Skylons. It was an establishment with significant access issues, as a steep flight of stairs ascended to the second floor, causing many a problem for groups transporting heavy gear. Furnished with old armchairs and overstuffed sofas located in dark nooks and crannies, the 45 became a favourite haunt for courting couples looking for privacy to partake in 'a spot of tonsil tennis and surreptitious grappling'. By the late 1960s it had become the psychedelic discothèque Samanthas, where the turntables were overseen by future Radio One DJ Andy Peebles, the last member of the British media to interview John Lennon before his murder in December 1980. It eventually became Bumbles for many years and then Jalarra until it finally closed. After a period of inactivity, the premises reopened as the Canvas Loft Bar and hosts live music once again after a break of nearly forty years.

20. Westbourne Arcade

Opened in January 1885, the Grade II listed Westbourne Arcade is a stunning example of Victorian design by Dorset journeyman carpenter Henry Joy, who also worked on Bournemouth Arcade. It is described as a 'well-preserved polychrome Gothic shopping arcade'.

Linking Poole Road and Seamoor Road, the glass-roofed Arcade cost £18,000 to build and included twenty-four shops and houses. It took several years to be fully occupied but was reported to be 'flourishing' by 1890. During the Second World War a nearby bomb caused the glass roof to shatter; it was eventually replaced after the war. It still boasts some original features including gargoyles on top of the drainpipes.

Among the wide range of shops and cafés currently open, the Arcade is home to The Colosseum, which is the UK's smallest cinema.

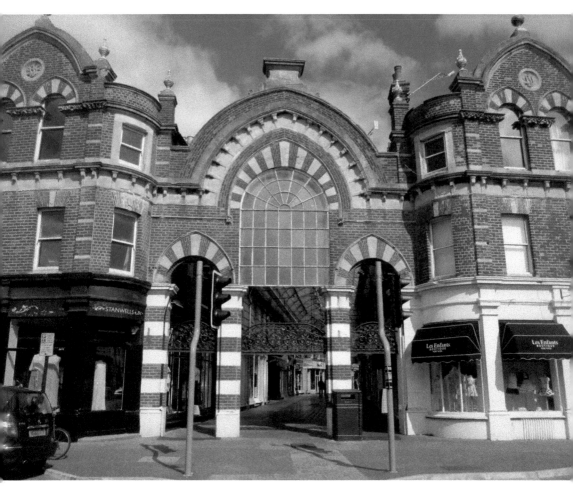

Westbourne Arcade.

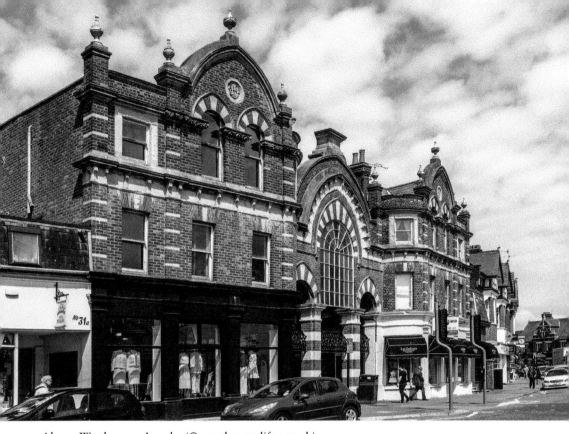

Above: Westbourne Arcade. (© westbournelife.org.uk)

Below: The interior of Westbourne Arcade – still 'flourishing'.

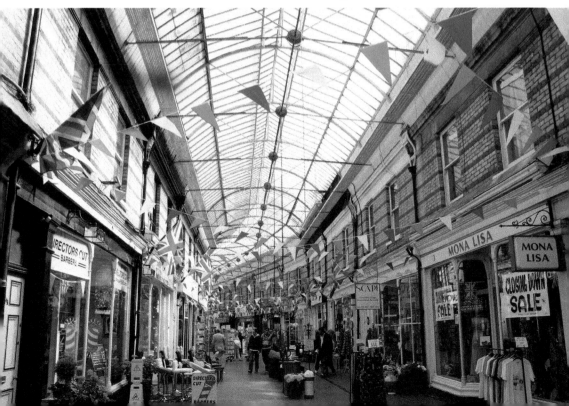

21. Bournemouth and Boscombe Piers, Including the Hemingway Beach Huts

Boscombe Pier

A pier for Boscombe was first proposed in 1884, but it was a few years later before it was opened. The Boscombe Pier Company was initially formed in 1886 and the first pile was laid on 11 October 1888. Designed by Archibald Smith, the 600-foot pier opened on 28 July 1889 by the Duke of Argyll. Constructed in wrought iron, it included the pier head of 120 feet, which had landing stages for the excursion steamers. Initially, the pier was not successful.

The local council took over the pier in 1904 and erected buildings at the entrance and on the pier head. In 1924–25 and 1927 the head was renewed in high alumina concrete. During the Second World War the pier was partially dismantled to prevent it being useful to enemy invaders, then rebuilt between 1958 and 1960, when the neck was reconstructed using reinforced concrete, to a modern design by the borough's architect, John Burton.

A restaurant and the Mermaid Theatre were built at the pier head in 1961 although the theatre, in fact, opened as a covered roller skating rink for its first two seasons. In April 1965, the leaseholder, Cleethorpes Amusements, converted it into an Arcade. The council formally took over the Mermaid Theatre in 1988 when the lease ended.

From June 1982, the council began pursuing a policy of joint redevelopment with private leisure organisations with a view to reconstructing the pier head, which eventually closed on safety grounds in 1990. The neck of the pier remained open, but the Mermaid Theatre closed in 1989 as it was just used as a storage area, and was eventually demolished. In 2008, the area around Boscombe Pier

Boscombe Pier – an oversized coffee table?

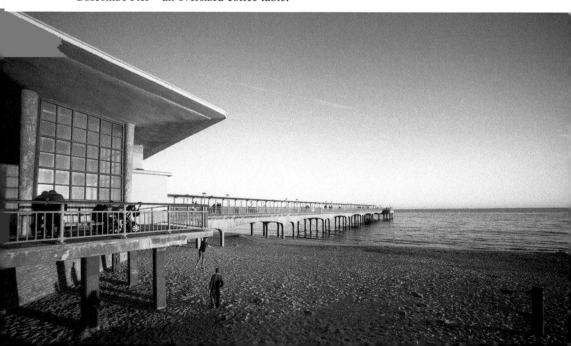

underwent extensive renovation. With the theatre demolished, it was eventually replaced by a simple viewing and fishing platform. The rest of the pier was also restored.

Nearby, construction of Europe's first artificial surf reef was completed and restoration work took place on the nearby Overstrand buildings. The area was now attracting a growing number of surfers, although the artificial reef, designed in the form of a giant sand-filled bag, was not especially successful.

In June 2010, at the National Piers Society's annual general meeting at Bournemouth, they awarded Boscombe the Pier of the Year award. The entrance building to Boscombe Pier has raised a number of comments over the years, built in an art deco style and often being resembled to an aircraft's wing or an oversized 1950s coffee table. An excellent example of retro-moderne architecture, it too has been restored to its former glory as part of a major regeneration scheme.

Beach huts have also been a prominent feature of the seafront at Bournemouth since the 1930s. They vary in style from the traditional, wooden, shed-like constructions to the ultra- modern, concrete terrace-style huts. The 1950s-designed concrete Overstrand beach huts have recently been revamped by Wayne and Gerardine Hemingway, founders of the Red or Dead label, as Beach Pods for the new surf reef at Boscombe. These Beach Pods are currently retailing between £65,000 and £90,000 and are for day use only. Each Beach Pod has its own unique retro artwork on the walls and is supplied with kitchen units, a kettle, microwave and chairs and wind breaks specifically designed by Wayne Hemingway.

The award-winning Boscombe Pier. (© Clive Wright)

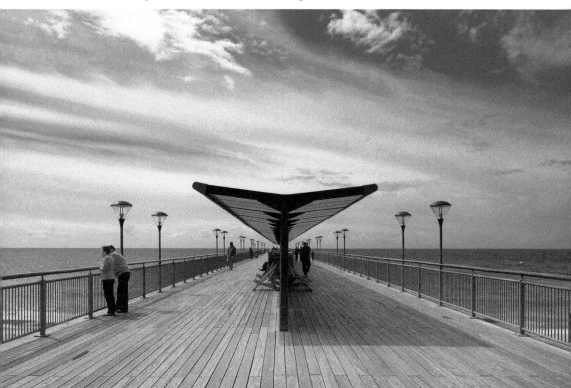

The Overstrand, Boscombe, redesigned by the Hemingways. (© Mark Watkin)

Bournemouth Pier

The pier is the iconic image whenever people think of Bournemouth and is predominantly used by the media whenever describing hot bank holidays when thousands of sun worshippers flock to the golden sands of the world-famous beach. The first pier was a very simple wooden structure, with only a length of 100 feet, and was erected in 1856. This was replaced in 1861 by a wooden pier at 1,000 feet long and was designed by Scottish sculptor and politician George Rennie. It was opened on 17 September that year at a cost of £3,418. This too was eventually demolished, with a cast-iron pier replacing it that was designed by Eugenius Birch and opened in 1880. It was further extended in 1894 and 1905, providing landing stages for the many excursion steamers that were now prevalent in Bournemouth.

The pier was a place to promenade and take the sea air while admiring the beautiful views. Bournemouth's motto is *'Pulchritudo et Salubritas'* meaning 'beauty and health'. In the 1930s visitors could board one of the steamers that sailed around the bay – the *Lorna Doone* or *Bournemouth Queen*. During the Second World War, the pier, like many others, was sectioned by an army demolition team in 1940 with the constant fear of a German invasion. Eventually, it was reopened after the war and refurbished in 1950.

In 1960, the Pier Theatre was added, designed by Elisabeth Scott, who also designed the Royal Shakespeare Theatre in Stratford-upon-Avon. It was designed to look like an ocean liner and provided traditional end-of-the-pier entertainment, hosting famous entertainers of the day for the summer season. Sadly, the original Victorian entrance building disappeared, replaced with an acceptable well-proportioned red-brick and Portland stone building which also made way for the current leisure complex.

The theatre closed in late 2013 and was re-opened in May 2014 as the RockReef Adventure Activity Attraction which offered 'Clip 'n' Climb' climbing walls, an aerial obstacle course and 65 metres of pier caves plus a terrifying vertical drop slide, a leap of faith jumping challenge and a cafe. Completing the transition of this historic structure into the twenty-first century was the installation of the world's first pier-to-shore zip wire in August 2014.

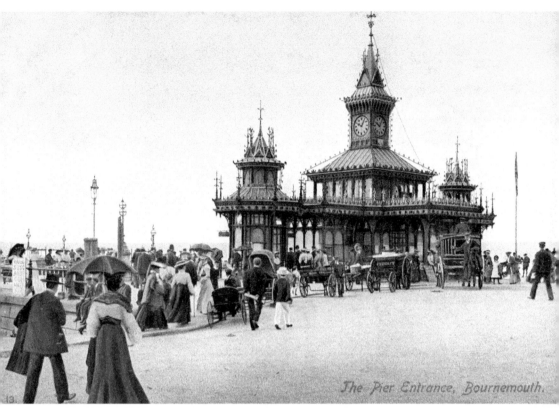

Above: The pier entrance, long since gone but very 'Victorian'.

Below: The current pier entrance.

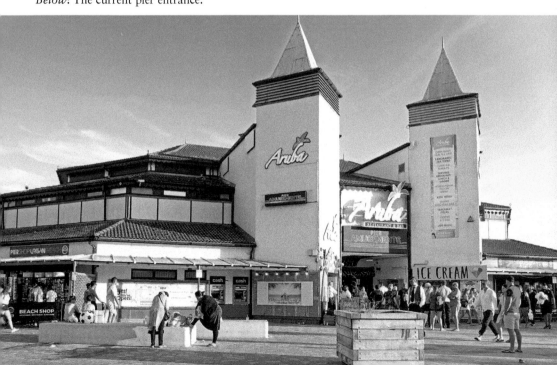

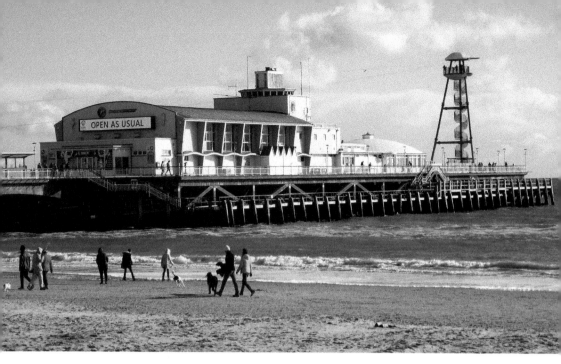

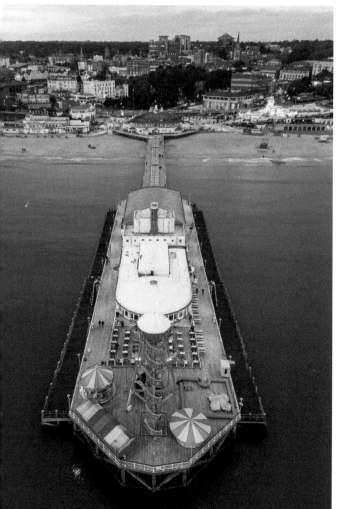

Above: A popular view of Bournemouth Pier.

Left: An aerial view of Bournemouth's most famous landmark. (© Darren Tennant)

22. Former Bournemouth Theatre Royal, Albert Road

The formation of the Bournemouth Theatre and Opera House Company in 1881 led to the construction of the first purpose-built theatre in the town. Described as 'a handsome and well-appointed Theatre', the Theatre Royal Bournemouth opened on 7 December 1882, in the heart of the town on Albert Road. Design and construction of the new building was by Samuel Edward Kemp-Welch (1847–88) and Reginald George Pinder FRIBA (1854–98), architects based in Old Christchurch Road, together with W. Nightingale of London. It cost £10,000 and seated 800 between stalls, dress circle, upper circle, pit, gallery, and private boxes. Unfortunately, it was not a financial success.

In 1887, the Improvement Commission moved in and for five years it doubled as the Town Hall, although dramatic performances continued throughout this period. Following refurbishment in 1892, it returned to being a full-time theatre once again, and prospered thereafter as the Bournemouth Theatre Royal and Opera House. During the Second World War, the theatre became a services club but sadly suffered fire damage in 1943 and was reconstructed. In 1949, it reopened as the New Royal Theatre. This incorporated the Premier News Theatre (a newsreel cinema). In July 1962, the theatre was converted to the Curzon cinema and bingo club, and in 1971 'twinned' as the Tatler cinema club. A casino now operates in the lower part of the theatre, while the (balcony) cinema closed in 1982 and became a nightclub in 2005.

The former Theatre Royal was the Town Hall for a time.

23. Bournemouth Town Hall

Now the borough's Town Hall, this fine building was originally a hotel. The foundation stone was laid by King Oscar of Sweden in 1881 and it opened as the Mont Dore Hotel in 1885 (named after the French spa town in the Auvergne, which pioneered the Mont Dore Cure). It had hot and cold salt baths supplied with seawater that was pumped all that way from the sea. It was built in a French and Italianate style as a sumptuous health spa primarily for rich consumptives by Dr Horace Dobell (one of the first four doctors in Bournemouth who had come to live in the town) next to the Sanatorium in what was then called Sanatorium Road, and achieved worldwide fame. It included Turkish and other baths, a winter garden comprising a covered lawn and tennis court, and a concert hall. As a measure of its importance, it boasted Bournemouth telephone number 3. Its use as a convalescent home for wounded officers during the First World War was, therefore, quite understandable. It was requisitioned by the War Office on 20 November 1914 for wounded members of the Indian Army Corps serving in France. Following their withdrawal a year later, it became a British military hospital and then a convalescent home for officers repatriated from prisoner-of-war camps in 1918. It closed as a hospital in 1919 and was bought by the Corporation to become the third Town Hall in 1921 (the previous one was where the Criterion Hotel/Arcade stood on the corner of Old Christchurch Road and Albert Road). It was converted by architect Alfred Bedborough, with the council chamber added circa 1930. Its interior is equally fine with an entrance hall, originally the carriageway of the hotel, and has a coffered vaulted ceiling, internal porch and ornate kiosk desk.

Mont Dore Hotel, now Bournemouth Town Hall.

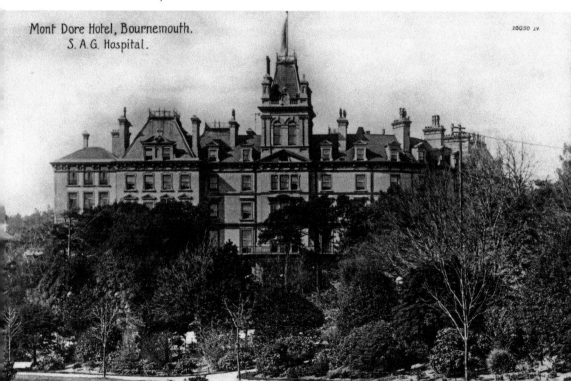

Mont Dore Hotel, Bournemouth.
S. A. G. Hospital.

20050 JV

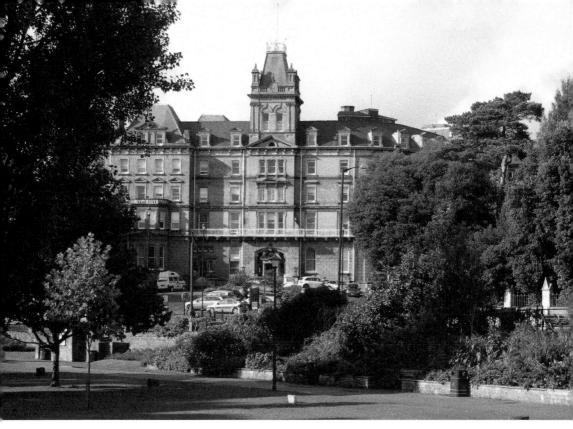

Above: The Town Hall from the Bournemouth Gardens.

Below: Looking down towards the Town Hall.

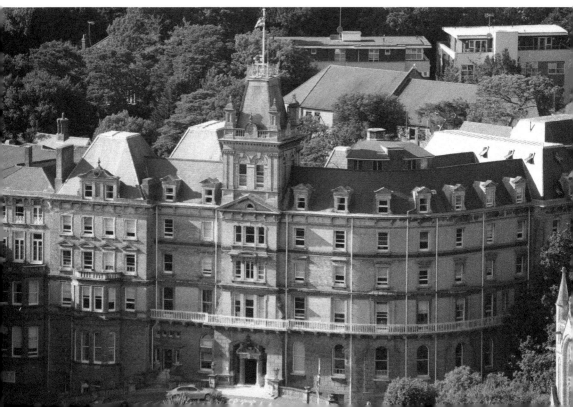

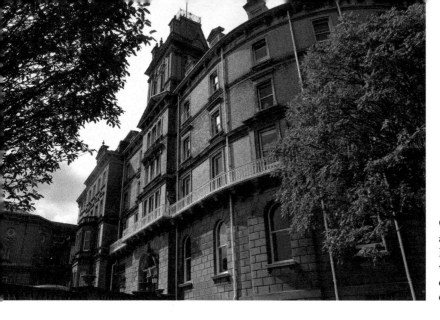

Converted by architect Alfred Bedborough, with the council chamber added circa 1930.

24. Bournemouth Central Railway Station

Situated on Holdenhurst Road, the station that serves the town originally occupied two sites on either side of the road. It was designed by William Jacob, chief engineer with the London & South Western Railway 'to resemble a winter garden', with brick construction and a glass canopy 40 feet up, 350 feet long and 100 feet wide with glazed ends. It is a fine example of Victorian design and architecture that befitted the image of the town at the time.

Central station.

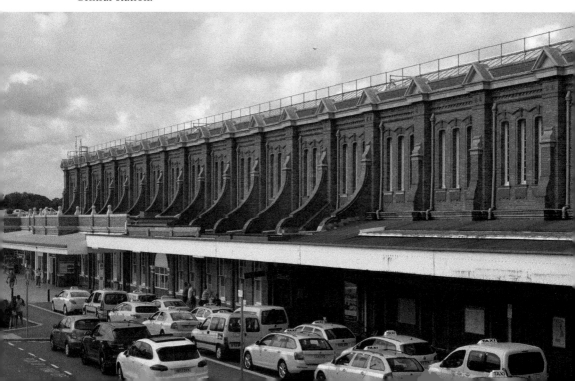

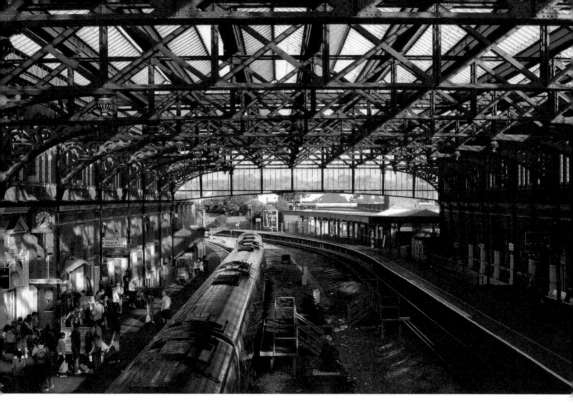

Ironwork in Central station.

Renamed as Bournemouth Central in 1899, it changed to simply Bournemouth in 1967 when Bournemouth West station was closed. Bournemouth was hit by the great storm of 1987 and the roof of the station was badly damaged. Railtrack refurbished the station in 2000 after years of neglect to restore it to the impressive building it is today.

25. St Andrew's United Reformed Church

In one of the most commanding positions in town, a new church was commissioned on land donated by Mr G. Durrant, who owned land in the Lower Gardens. Public subscriptions were requested and the sum of £1,200 was raised and work commenced on a new church designed in the Gothic style by architect Mr Christopher Crabbe Creeke. There were troubles associated with the new church including legal issues and rights to the land and, once completed, even finding a pastor was challenging. Finally completed and opened on 8 March 1859, the church immediately became successful, although some choices of pastor left a lot to be desired. As the congregations grew a larger church was required and, on 24 November 1891, the present church was opened. It was designed again in the Gothic style by Messrs Lawson and Donkin at a cost of £12,000.

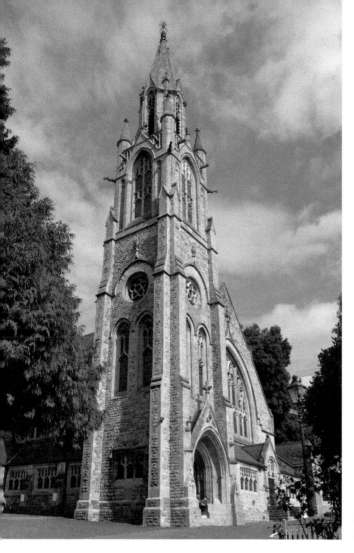

St Andrew's United
Reformed Church.

26. Granville Chambers, Richmond Hill

The Granville Chambers were built as a Temperance Hotel by local architects
and builders Lawson & Donkin in 1891 and remained as a hotel up until 1930,
although some research suggests this was actually earlier; certainly, from 1930
the building was used as offices. Lawson & Donkin also designed East Cliff
Congregational Church, Richmond Hill Congregational Church, the Unitarian
Church in West Hill Road, some of the interior of St Peter's Church, Granville
Chambers and the Central Hotel on Richmond Hill, the Theatre Royal in Albert
Road, Boscombe's Royal Arcade, the Hippodrome and Salisbury Hotel. The firm
were active in Bournemouth from the 1880s to 1930. The building was Grade II
listed in 1974 and its listing highlights its Franco-Flemish red brick and buff
terracotta, and its terracotta sculptures, which includes lions with swags in teeth
and fern-like foliage in window spandrels. The building is now used as offices.

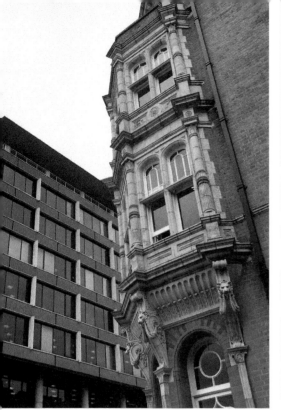

Above left: Granville Chambers, contrasting with the adjacent modern office development.

Above right: Franco-Flemish red brick and buff terracotta – one of the reasons why the building is currently listed.

27. Royal Arcade, Boscombe

The commercial centre of Boscombe had a major boost through a number of projects by Archibald Beckett, including blocks of shops, the Salisbury Hotel, the Royal Arcade and a Grand Theatre. These were all built between 1888 and 1895, and shortly after opening in 1892 the Royal Arcade was lit by electricity. Boscombe Arcade was built at a cost of £40,000 and was designed to attract shoppers to Boscombe from the town centre.

Opened on 27 May 1895, the Grand Pavilion Theatre originally seated 3,000 people. It became the Boscombe Grand Theatre in 1899 and, in 1905, the Boscombe Hippodrome. The change courted controversy as an outraged shop owner sited opposite erected a statue of Old Nick on his roof with the inscription 'The Devil Comes Into His Own', as he believed the venue lowered the tone of the town. Over the years, performers such as Sarah Bernhardt, Max Miller, George Formby, Charles Hawtrey, Laurel and Hardy and the local lad himself, Tony Hancock (he lived at the Durlston Court Hotel in Gervis Road, now the Celebrity Hotel) all graced its stage.

After the Second World War, the Butterworth family bought the premises and reallocated its use to a dance hall called the Royal Ballrooms in 1957. For a short

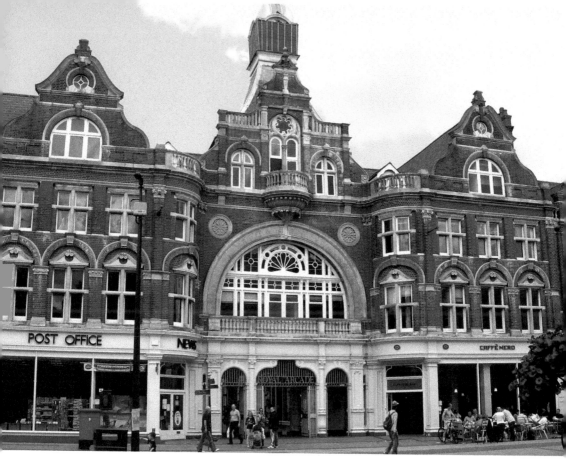

The Royal Arcade in Boscombe.

spell during the 1970s the venue hosted gigs by bands such as David Bowie and the Spiders From Mars, Slade, Thin Lizzy, Status Quo, Deep Purple, Rod Stewart and The Faces, Canned Heat, T Rex, Fleetwood Mac, The Kinks and, most memorably on 2 December 1971, Led Zeppelin, with tickets at £1. But it didn't last. Over the next thirty years it was leased to Mecca then Rank who rebranded the venue as Tiffany's. In 1982, it became the Academy and then, in 1997, the Opera House, which hosted Frankie Goes to Hollywood and the Sisters of Mercy among a host of others. After a wonderfully anarchic gig by the reformed Bonzo Dog Band in 2006, the venue closed for a £3.5 million refit, and it is now operated by the O2 franchise.

28. House of Fraser and Former Dingles, Gervis Place

Along with Bobbie's and Beales, Brights of Bournemouth was one of the jewels in the town's shopping crown. It started humbly, as many of the grandest emporia did, in 1871. Frederick Bright opened a store selling needlework and Berlin wool at No. 9 The Arcade and later expanded into the next-door premises at No. 8. By 1894, F. J. Bright & Son occupied four shops in The Arcade, later opening a

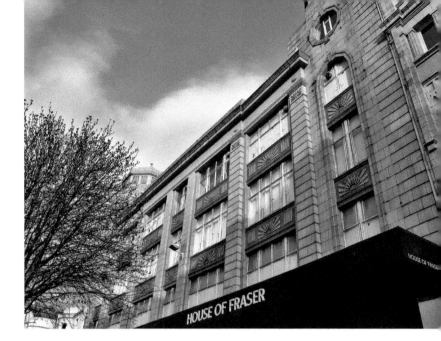

The former
Dingles store,
now the House
of Fraser.

newly built stationers and a fancy goods store (with its own restaurant) in an
adjacent building. Bright had been a missionary in India until ill health forced
him back to England and he settled in Bournemouth, which was famed for its
health-giving air.

Brights' expansion continued apace, including the addition of a gent's outfitters,
drapers, costumiers and photographers, and in 1905 the building was enlarged
to the south with an addition of five floors fronting onto Gervis Place. Back on
Old Christchurch Road, the architect embraced the mania for all things Egyptian,
in vogue at the time, and set Egyptian motifs on the building, which was clad
in Glam cream tiles from Carter & Co. in Poole. It is one of the reasons it is
listed today.

In-store, everything was just as elegant. Shoppers were treated to fashion
parades of the new season's must-have looks and, one year, the ambitious show
even included the stunning 1935 Auburn car, which had starred in a movie with
Marlene Dietrich and was lent by Beauliieu Motor Museum. In 1960 the store
was purchased by the J. J. Allen group, which itself was snapped up by House of
Fraser in 1969. The store was hived into its Dingles division, comprising shops in
the West Country. Then, in 2007, the store was renamed again as House of Fraser.

Like the town's other stores, Dingles is remembered fondly as a focal point of
Bournemouth's retail scene.

29. St Stephen's Church

One of the finest buildings in Bournemouth is St Stephen's Church, which
is especially well known for its Gothic architecture and its architect, John
Loughborough Pearson. The church itself was built by public subscription as a

memorial to Alexander Morden Bennett, first vicar of St Peter's, who died in 1880. On 11 October 1881 the foundation stone was laid and dedicated by Bishop Harold Browne of Winchester. This date is still observed as the dedication festival of the church.

Before the church was built, there was a mission church to the south of the present building on some high ground, part of which has been removed to make way for Braidley Road. The church was not built all at once. A beginning was made with the nave and aisles, which were consecrated in June 1885. The chancel and lady chapel were begun in 1896, the foundation stone being laid by Sir George Meyrick on 10 June, and finished in 1898, when it was dedicated by Bishop Sumner, Archdeacon of Winchester.

The church is a stunning example of the works of its architect, who also designed Truro Cathedral. Pearson, when designing Truro Cathedral, is said to have told a friend that he wished to build a church that would bring people to their knees. This is what many people assert to be the impression made on them as they enter St Stephen's Church. To Pearson, quality was infinitely more important than quantity and, even with the vast influx of work that followed his appointment at Truro, he still maintained a high standard. It is said he would not be connected with more than two churches at a time, and another architect relates how Pearson told him he 'would rather build one church well than attempt half a dozen indifferently'.

St Stephen's Church, a church designed to bring people to their knees.

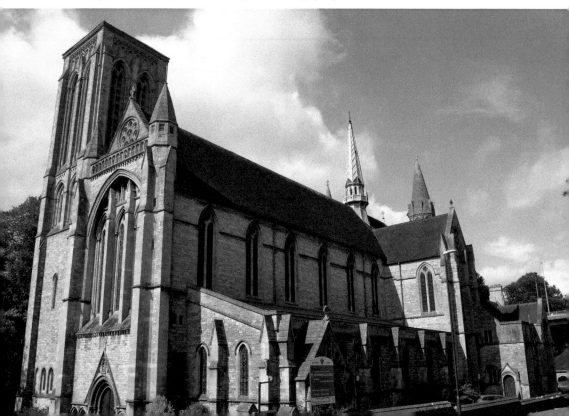

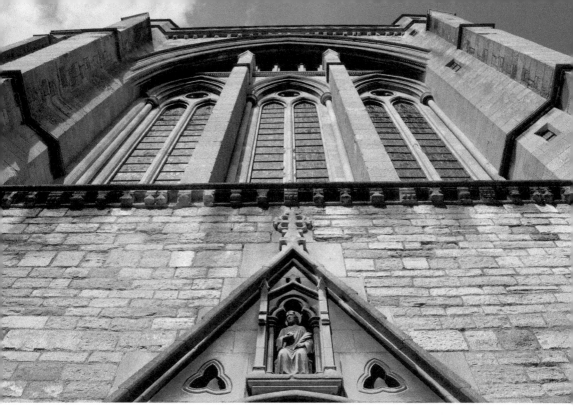

Above: Gothic architecture and famous for its architect John Loughborough Pearson.

Right: St Stephen's Church was dedicated by Bishop Harold Browne of Winchester.

30. Former Pokesdown Art and Technical School

Built in an ornamented Italian Renaissance style, this remarkable building is notable for its architectural detailing and composition. It was built as the Pokesdown Art and Technical School. The school was founded in 1897 and the wonderful building erected in 1898. It was felt at the time that with so many children leaving school at twelve years of age, it was considered that more education, particularly in science and technical subjects, was required for the children of the increasing number of artisans in the Pokesdown district. The foundation stone for the art and technical college was laid by Abel Henry Smith MP on 14 September 1898. The cost of the building was around £2,500, with the funding provided by a group of local people.

In 1985, Bournemouth Helping Services Council formed Help and Care which moved to the former school in 1994. In 1996, Help and Care purchased the building.

Built in Italian Renaissance style, the former Pokesdown Art and Technical School. (© Alwyn Ladell)

31. Bournemouth Collegiate School

Bournemouth Collegiate School was established in 1899 in Poole to provide non-denominational education for young ladies with a strong Christian ethos (and with links to the United Reform Church). It was originally called Bournemouth Collegiate School, but after its move to much larger and grander premises at Wentworth Lodge in 1923, it gradually came to operate as Wentworth School, and fully met its target of offering a broad and high-quality education to a growing number of day and boarding girls. The boarding facilities are built around the old Wentworth Lodge, in which Wentworth College was housed and which were once part of the Portman estate. The house, built in 1872, was used by Viscount Portman as a summer residence for around six weeks every year.

The school was evacuated to Wales during the Second World War, and then returned to Bournemouth to continue its steady growth.

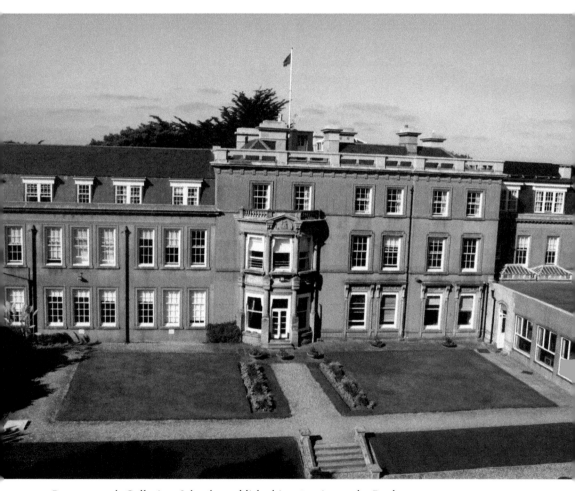

Bournemouth Collegiate School, established in 1899 in nearby Poole.

32. Russell-Cotes Art Gallery and Museum

Sir Merton Russell-Cotes is one of the town's most pioneering residents, a man who had many progressive ideas and who became a great benefactor to the town he loved. He is especially remembered for the outstanding Russell-Cotes Art Gallery and Museum, previously East Cliff Hall. He was born on 8 May 1835 in Staffordshire and, from his earliest days, was obsessed with objects of art, antiques and curios, further stimulated by the Great Exhibition of 1851.

After his father died, he went to live in Glasgow with his sister and her husband who became his guardians. When he was eighteen years of age, he discovered he had congestion of the lung and, on medical advice, spent a period of time in South America. He was to travel throughout the world, often in search of better health, and collected paintings and curios at the same time.

Returning, he was appointed secretary to the Scottish Amicable Society in Dublin and became the manager of the Royal Hanover Hotel in Glasgow. Poor health was still an issue and resulted in him visiting resorts on the south coast, including Bournemouth. It was here that he was persuaded to buy The Bath Hotel, the first hotel built in Bournemouth, eventually taking possession on Christmas Day 1876. One of the inducements to buy the hotel was that he would be able to indulge his passion for art and his love of buildings and property development. It was this incentive of creating an opportunity to form an art gallery to house his many treasures, and also his loan collection of 250 paintings, borrowed by different galleries across the country that persuaded him to buy the hotel.

Russell-Cotes began to enlarge the Bath Hotel with new wings added by town surveyor Christopher Crabbe Creeke. The hotel was reopened on 11 August 1880 as the Royal Bath Hotel by Sir Frances Wyatt Truscott, the Lord Mayor of London, who was in Bournemouth the same day to open the new pier. The hotel soon became known for displaying much of his magnificent collection. By 1891, Russell-Cotes was invited to become mayor, which he sadly turned down due to controversy with his Undercliff Drive scheme. Further invitations were made and all refused until 1894, when the council agreed to support his plans on the condition he accepted the appointment as a magistrate in addition to that of mayor.

In celebration of these events, and as a birthday present to his wife, Russell-Cotes commissioned the building of a magnificent hall on the East Cliff, facing the sea, which began in 1897 and was completed in 1901. East Cliff Hall was to become the home of Merton and Annie Russell-Cotes. The house was designed in the art nouveau style by the architect John Frederick Fogerty, but Merton and Annie had a great deal of input into the design. It was designed so that the couple could live in style and comfort and to house their growing collections. The house was to be a showcase, not simply for their own enjoyment, but also for the people of Bournemouth to whom it was given. On 15 July 1901, Merton presented East Cliff Hall to his wife as a gift on her sixty-sixth birthday. This was the same year that Queen Victoria died, making the house one of the last Victorian buildings

ever built. It was an extraordinary, extravagant birthday present – lavish, splendid and with a touch of fantasy. They filled this exotic seaside villa with beautiful objects from their travels across the world and lined the walls with a remarkable collection of British art, creating a unique atmosphere in a most dramatic setting. It was to become a home, an art gallery and a museum.

In 1907, Annie Russell-Cotes donated East Cliff Hall and its contents as a museum to the town of Bournemouth and Merton in turn donated his fine art collection. In return, they were made honorary freemen of the town. They continued living in part of the house and, over the next ten years, they paid for an extension to be built and made further donations including the freehold of the site. It was formally opened by Princess Beatrice in 1919. After their deaths, the borough of Bournemouth took over the running of East Cliff Hall and reopened it as the Russell-Cotes Art Gallery and Museum on 10 March 1922. After Sir Merton's death it was extended into his part of the house; a further extension was opened in 2000. The house and the new annexe display various items collected in the course of Sir Merton's foreign travels, especially from Japan and paintings from his personal art collection. Today it is one of Bournemouth's most popular visitor attractions.

The Russell-Cotes Art Gallery, the former home of Merton and Annie Russell-Cotes.

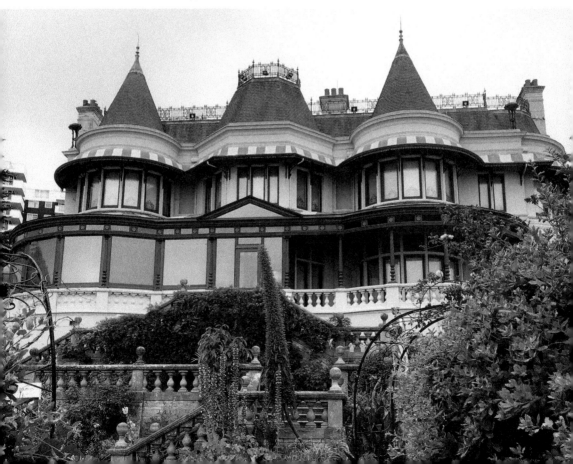

One of the last Victorian buildings to be built in Bournemouth. (© Belinda Fewings)

33. The Old Fire Station, Holdenhurst Road

The Old Fire Station in Holdenhurst Road is exactly that. Now home to Bournemouth University's Students' Union nightclub, this beautiful example of red brick and stone Edwardian architecture was built in 1902 by the borough surveyor, F. W. Lacey, who also designed the Bournemouth Municipal College just a little further up the road.

From the late nineteenth century, Bournemouth, like most brigades in the country, used horse-drawn appliances. They took delivery of their first motorised vehicle in 1913, with a full motorised fleet operational in the 1920s, but the firefighters still had to travel in the open. In the 1930s enclosed vehicles were eventually introduced across the UK. When the local government was reorganised in 1974 and Bournemouth moved from Hampshire to Dorset, the service merged with Christchurch and became Dorset Fire and Rescue Service.

The building was given Grade II listing in 1987, fifty years after it was extended, and this was celebrated through a rally and open weekend when a number of old appliances travelled from Bournemouth to Poole and there were firefighting displays and tours around the station.

The Old Fire Station today is a permanent and popular fixture on the town's nightclub scene for students and visitors alike.

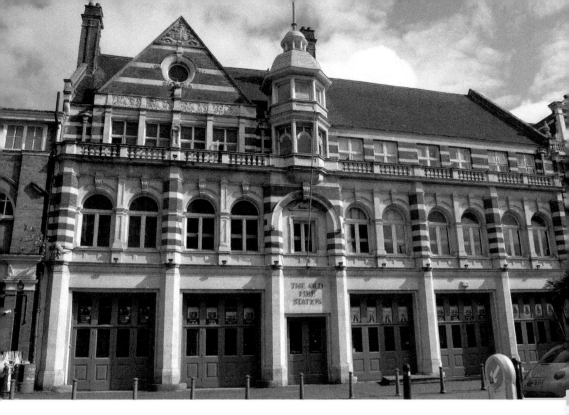

Above: The Old Fire Station on Holdenhurst Road.

Right: A Grade II listed building, and now a Students' Union nightclub.

34. Branksome Arms, Poole Hill

The wonderful Branksome Arms on Poole Hill was built around 1905 and displays a brightly coloured tiled advertisement for Eldridge Pope's Dorchester Ales in its *porte cochere*; the brewer's arms lie within a green oval on a yellow background, surrounded by ornate scrollwork. The pub's main façade is a cheerful combination of green glazed brick with pale grey Carter's ceramic marble dressings.

The Branksome Arms on Poole Hill.

The building is now listed and is described as a 'Public house. c1905. Green glazed brick or tile, pale cream faience; roof not visible from street. Art Nouveau crossed with Edwardian Baroque. ... with original faience lettering 'Branksome Arms' to central pediment ... A wilful facade, very characteristic of the period.'

35. Gentlemen's Public Convenience, Holdenhurst Road

A rather unusual landmark with a notorious local history is the Grade II listed public toilet located at the junction of Shelbourne Close and Holdenhurst Road in the Springbourne area of Bournemouth. Designed in Edwardian Lutyenesque style and built *c.* 1905, this red-brick, circular building with four inclined brick buttresses and a concrete domed roof is set below the street and can be reached via a staircase. It is believed to have been built as a comfort stop for the tram drivers in the town who turned around at this point on the route.

It was permanently closed in 2017 and was put up for sale for £25,000 in January 2019. Another toilet block in the Triangle area of the town was sold in 2016 and converted into a restaurant.

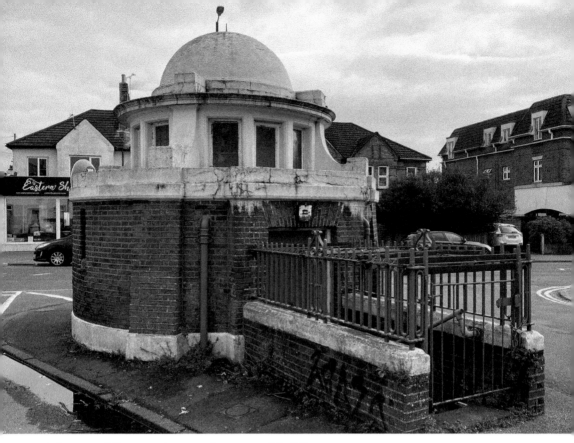

A former public convenience, and an unusual building.

36. Hotel Miramar

The Hotel Miramar was originally built as a private residence in around 1905. It was owned by the Austrian ambassador, who used it as a weekend home. It is built in the Arts and Crafts style, which was very popular at that time.

The house was converted into a hotel in the 1920s, when the two side wings were added. The name 'Miramar' is a Spanish word meaning 'view of the sea', and is certainly more than appropriate here. The hotel also played its part during the Second World War when the Miramar was used by the American Red Cross for US nurses, WACs and ARC girls.

However, the hotel has a famous connection with an internationally famous author. During the 1950s, '60s and '70s, the hotel was a favourite holiday home for the author J. R. R. Tolkien of *The Hobbit* and *Lord of the Rings* fame. He regularly stayed in what is now Room 205. A blue plaque commemorates this at the front entrance under the portico.

The Miramar has had a succession of owners over the years. Restored over many years, the hotel with its 'view of the sea' is one of the most popular in Bournemouth.

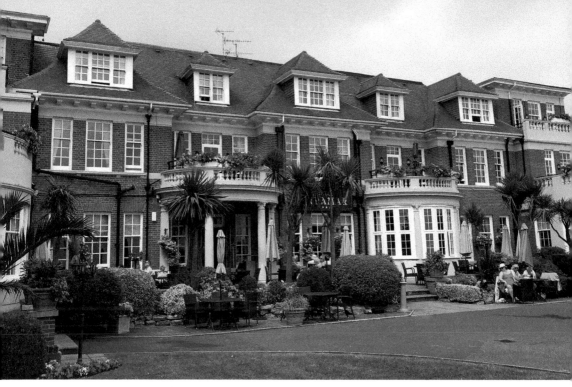

The Hotel Miramar, once popular with author J. R. R. Tolkien.

37. Former County and Coroners Court

In the late nineteenth century assize courts, county courts, petty sessions courts and coroner's courts were all often built in a Gothic style. Assize courts were among the grandest buildings in a town or city and would usually be located in the area occupied by other government buildings. Late nineteenth-century county courts were often located in the commercial district of a town. Although externally they might be treated with elaborate detailing, their form would indicate that this was an office building as well as a courthouse. Magistrates' courts were more frugal in appearance, an indication of their more humble status. Typically containing a single court, they were frequently adjacent to a police station. Purpose-built, dedicated coroner's courts began to be constructed during the late nineteenth century. The presence of royal arms may also denote that a building was the venue of a law court, although they also appear on other types of government buildings.

Bournemouth's former county and coroner's court was built between 1908 and 1914 by F. W. Lacey, borough surveyor, and H. A. Collins, in this instance in an Edwardian baroque style. It was also central to one of the lives of one of the country's most notorious murderers, Neville George Clevely Heath, a man described as 'the most dangerous criminal modern Britain has known'. While the police were hunting him for a murder he was holed up in the Tollard Royal Hotel. He befriended Wren Doreen Marshall, who he also went on to murder, and her body was found in Branksome Dene Chine. Having attempted to pawn

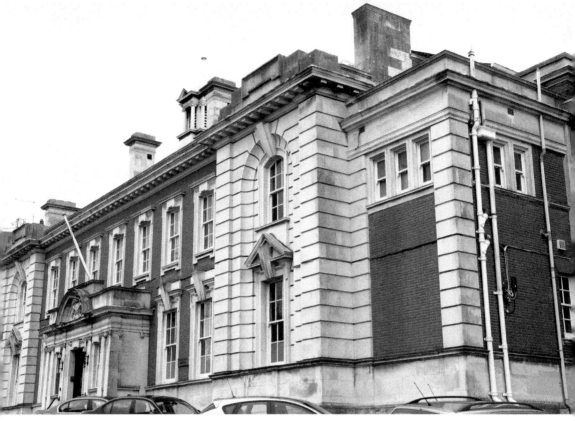

Another building by F. W. Lacey, borough surveyor, the former County and Coroner's Court.

Doreen's ring, he was recognised at Bournemouth Police Station when an officer noticed his resemblance to a photograph of Heath. He was arrested and charged with murder, then executed by hanging on 16 October 1946.

38. Bournemouth and Poole College, and Former Library

Sited in the Lansdowne area of the town is the magnificent Grade II listed building that now houses Bournemouth and Poole College, which opened in 1913. The original occupants were the Bournemouth Municipal College and Central Library. Up until 2002, the public library was housed here.

The college was designed by borough architect and surveyor F. W. Lacey on land purchased by Bournemouth Corporation from local landowner George Meyrick. The Meyrick family are still one of the areas wealthiest landowners owning many sites in Hinton and Bransgore, and who also own most of Bournemouth's famous seafront. The four-faced clock tower was a gift to the town from Mrs Croft, who was the mother of the local MP, Henry Page Croft. In 1893, the Public Libraries Act of 1892 was adopted in Bournemouth and the first Bournemouth Libraries Committee was appointed. In 1895 the mayor, Merton Russell-Cotes, opened a public library in Old Christchurch Road and then, in 1901, the Central Library moved to Dean Park Road.

The Central Library at the Lansdowne was built on the site of a house called Peachley, together with the municipal college, with the land costing £1,500 and the building £7,000. Opened by the Mayor, Alderman H. S. McCalmont Hill, in 1913, Lansdowne Library consisted of a lending library and a newsroom, a reference library and magazine room, the John B. M. Camm Reference Library, as well as offices.

Bournemouth College of Technology and Poole Technical College were brought together in 1974 due to a government reorganisation by Dorset County Council. The college now offers a sixth form centre and a wide range of vocational courses, workforce development, and business and professional studies from several sites in Bournemouth and also in neighbouring Poole, and it is the largest local provider of further education. Bournemouth Central Library eventually moved from the Lansdowne in 2002 to a larger state-of-the-art facility at the Triangle, an impressive glazed building that cost £9.5 million. The structure won the British Construction Awards 2003 and Prime Minister's Better Public Building Award 2003 and was shortlisted for numerous other government and design awards.

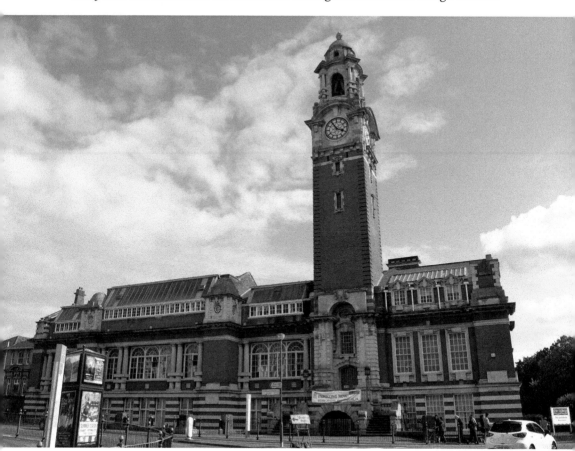

Bournemouth and Poole College, designed by F. W. Lacey.

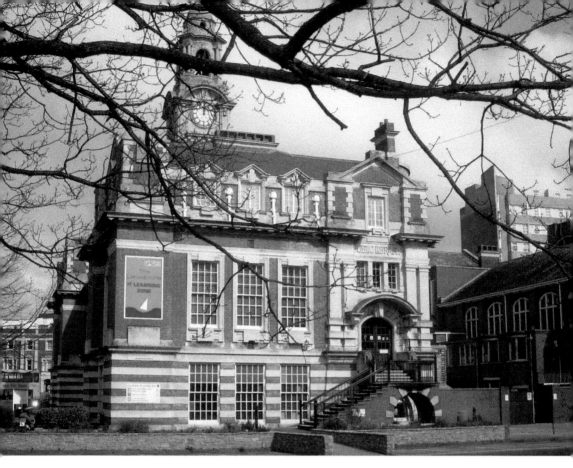

Above: Evidence of its previous use – a public library.

Right: The magnificent tower of Bournemouth and Poole College. The clock was donated by Anne Elizabeth Croft, the mother of the local MP Sir Henry Page Croft, in 1912.

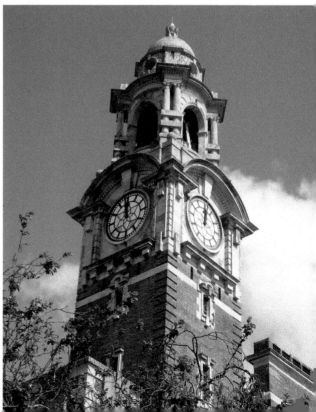

The new library, which moved to the Triangle area of the town in 2002. (© makeitbournemouth.co.uk)

39. Westbourne and Springbourne Libraries

Westbourne Library opened at the height of the First World War on 13 May 1916, a time of mass destruction that saw the lives of many changed forever. The library was to give the people of Westbourne 'a new centre of intellectual life and effort,' a sense of purpose against the futility of war.

It was more than twenty-one years since the first public library was opened in Bournemouth and thirteen years after Andrew Carnegie's generous gift to the town of £10,000 for the building of four libraries. Westbourne Library, planned since 1903, finally opened its doors. Springbourne Library, another Carnegie library, had also opened on 27 March 1909 by Mayor G. E. Bridge.

The opening ceremony of Westbourne Library was a prestigious event attended by the mayor of Bournemouth, Alderman Henry Robson, the Libraries Committee and Mr J. A. Longden, without whose generosity the library would never have been built.

Westbourne had been waiting for many years for a replacement to the temporary, makeshift library and reading room in Poole Road. However, Andrew Carnegie's offer came with the condition that 'no charge should fall upon the library rate for the purchasing or leasing of a site'.

At Westbourne, the difficulty was not only finding the money but also acquiring a suitable plot of land. In 1914, the Carnegie Trust withdrew their offer due

to the lack of progress in finding a site but, after an appeal in the local papers, Mr Longden purchased the site – the north portion of the garden of Wilton House on Alum Chine Road – and gifted it to Bournemouth Council.

The new library consisted of a newsroom, magazine room and lending library fitted with stands for 2,000 volumes. The walls of red brick with Poulton stone dressing were of grey distemper and the woodwork stained dark green and varnished. The cost of the build by Messrs Barnes & Pond was £1,887.

During the Second World War, a room in the library was used as a War Damage Office for the borough. The well-known British primatologist Dame Jane Goodall often visited the library in the 1940s when she attended Poole's Uplands School. It was not until 1963 that the library began opening full time. In 1976, Westbourne Library became a listed building and in the same year it was named 'Library of the Year' when still part of Dorset County Libraries.

Today the library has developed into a community hub, offering a venue for educational classes, meetings, CAB advice and legal services, while providing computer training, children's rhyme sessions, coffee mornings, reading groups and much more. However, the mayor's words spoken at the time, 'A public library fills a very great place in the education and recreation of any community in which it might be placed', still resonate today.

Westbourne Library dates from 1916.

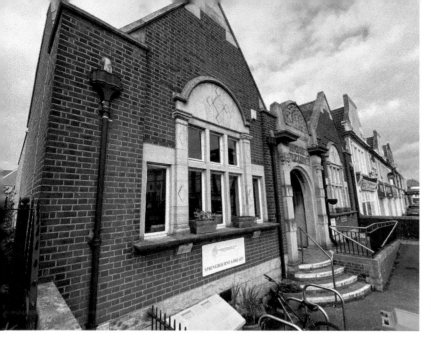

Springbourne Library, which opened in 1909.

40. Frizzell House, Westbourne

Frizzell House is a landmark building in the Westbourne area of Bournemouth but is actually almost in Poole. Its unusual design is certainly striking with the building located in the centre of a gyratory system, or large roundabout. Although the official title of the road is County Gates Gyratory, many still know it as the 'Frizzell roundabout' after the insurance company who were located there.

With both Bournemouth and Poole now in Dorset, the name 'County Gates' seems less relevant today. However, until the 1974 reorganisation of local government, Bournemouth was in Hampshire and adjacent Poole in Dorset. Westbourne, on the western edge of Bournemouth was on the county boundary – hence its name.

Frizzell Insurance was a family-run business founded in 1923 as a general insurance brokerage, later diversifying into banking and financial advice. It gained a reputation for providing bulk insurance services to trades unions, social clubs and the civil service motoring association. Primarily known for its household and motor cover insurance, it was sold in 1992 to the US Insurance Group Marsh McLellan for £107 million. By this time, it was one of the largest private employers in the area with over 1,600 staff, and it was the country's largest insurance company still privately owned.

The company has always been closely involved with the local community and supported a large number of local charities, with staff getting involved in fundraising. They also sponsored AFC Bournemouth for many years. A charitable company, now based in Maidenhead, Berkshire, it still exists today.

In 1996, the business was sold again, this time to Liverpool Victoria Friendly Society (now LV=) for £188 million. They still operate from this site in Bournemouth and a number of other buildings, which may just make it into Westbourne.

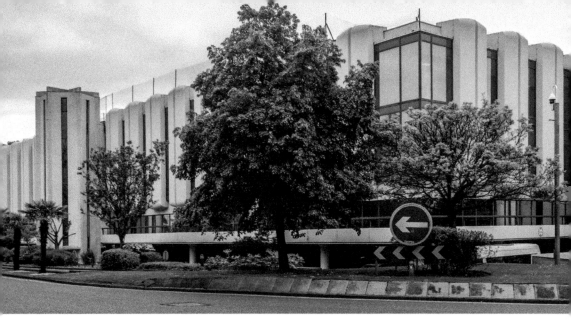

Frizzell House on the County Gates gyratory.

41. Pavilion Theatre and Ballroom

The influence of Merton Russell-Cotes was largely responsible for the interest in the building of the Pavilion. He had written to the local press in 1901 saying a 'seaside pavilion is an absolute necessity'. The deputation of 1903, headed by the mayor, Alderman J. E. Beale, had done much research on pavilions while working on the question of the Undercliff Drive. They reported 'a pavilion, embracing a concert room, reading rooms, cafes (indoor and outdoor refreshments) and all other accommodation and advantages found in the very best of the kind we have seen on our travels should be provided in Bournemouth.'

When this Grade II listed art deco building was finally officially opened several years later by HRH Duke of Gloucester in 1929 at a cost of £250,000, 'so wonderful was it that every national newspaper featured it'; the *Daily Telegraph* described the new complex as giving 'the impression of a balanced, square-looking structure' with 'a seemliness and dignity which Bournemouth will observe with quiet satisfaction'. The building is the epitome of much of Bournemouth's municipal architecture with its strong art deco influence, mixed with red brick and fine white Portland stone.

The Pavilion housed a stunning concert hall and tearoom with a sprung dance floor, which regularly hosted performances by the Bournemouth Municipal Orchestra, the predecessor of the world-famous Bournemouth Symphony Orchestra. The Compton organ, still in use today, charmed the audience amid plush décor 'painted in warm and relaxing pastel shades of pink and terracotta with gilt ornamentation' including beautiful glass chandeliers, which were removed during the Second World War in case of damage.

It remains an elegant home to a hugely popular annual pantomime, summer shows, concerts, West End stage shows, opera, ballet, and comedy as an additional venue to the Bournemouth International Centre.

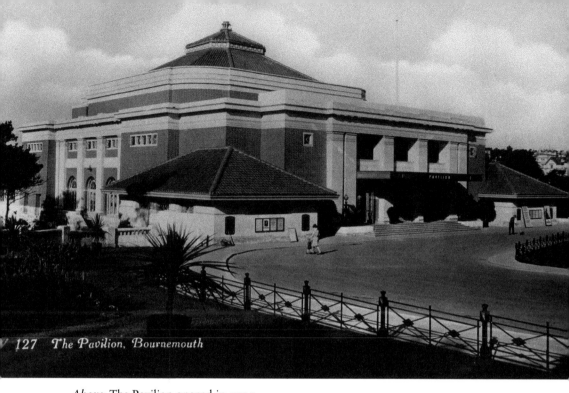

127　The Pavilion, Bournemouth

Above: The Pavilion opened in 1929.

Below: The Pavilion from the Lower Gardens.

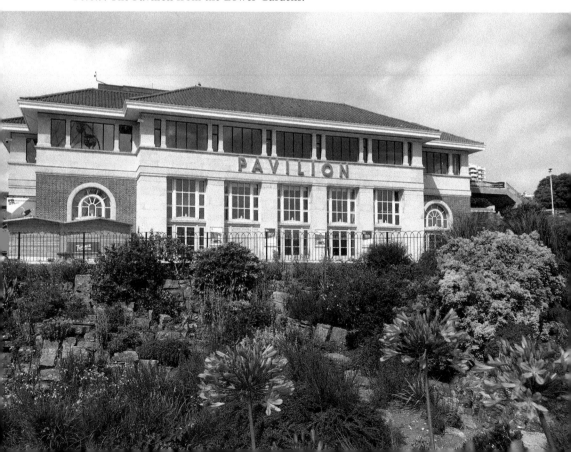

42. San Remo Towers, Boscombe

In 1935, three years of construction started on the San Remo Towers block of 164 flats between Sea Road and Michelgrove Road. The six entrances are impressive, with surrounds of candy-striped Carter's faience in barley-sugar engaged columns. The five blocks were identified by faience lettering (A to E and the main entrance) and were partly faience tiled. Facilities for residents included central heating, an 'auto vac' cleaning system, a resident manager, a porter, daily maid, boot cleaning and window cleaning services. There was a residents' club with a reading room, card room, billiard room and library, a children's games room, a shop and a restaurant. The rent in 1938 was £96–260 per annum.

The block is now Grade II listed and was designed by British-born architect Hector Oliver Hamilton, FRIBA, for Armstrong Estates of Guildford, in a Los Angeles Spanish style. Hamilton had worked in New York for Hamilton and Green in the early 1930s, and came to prominence in 1932 when the Soviet Union awarded him first prize alongside two Soviet architects for his design for the Palace of the Soviets in the second round of a public design competition – only to cancel the award without explanation a few months later!

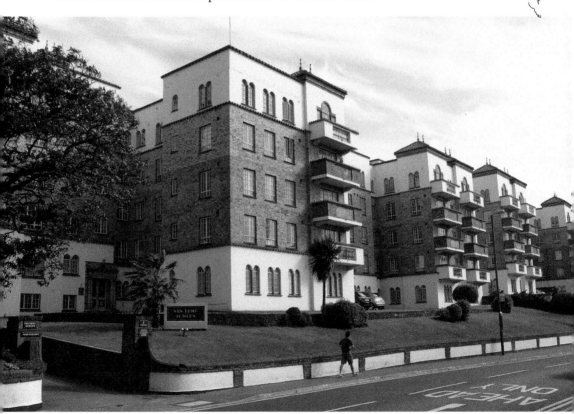

San Remo Towers, designed in a Los Angeles Spanish style.

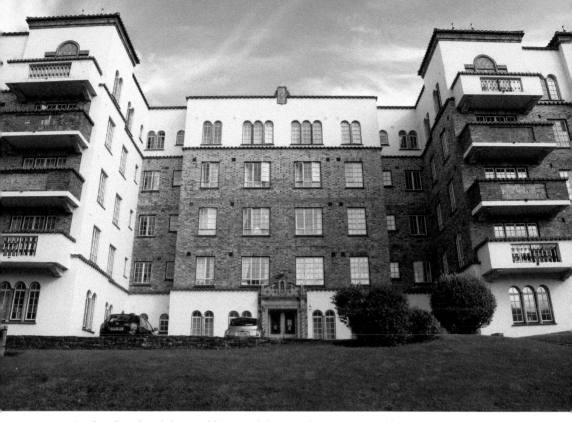

Grade II listed and designed by British-born architect Hector Oliver Hamilton.

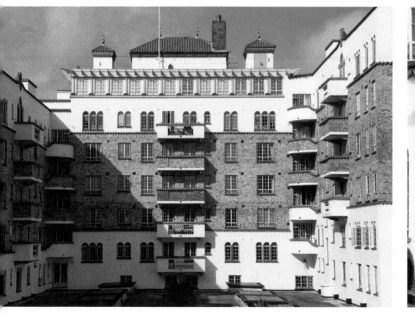

Above left: San Remo Towers, popular with residents who were provided with many facilities.

Above right: Faience-tiled Entrance B.

43. Bournemouth's Art Deco Buildings

The Echo Building

Built in 1932 by architects Seal and Hardy, there can be few buildings that so beautifully reflect the art deco influence in the town, with its central tower, streamlined corners and metal-framed windows. It has been home to the local newspaper, the *Daily Echo*, since 1934, which has been supplying news to the local population since 1900. Bestselling author Bill Bryson was a reporter for the *Echo* in the 1970s and was awarded an honorary doctorate from Bournemouth University in 2005. This Grade II listed building was the 10,000th to be enriched – where the public add information or images on the Historic England online list of historic buildings and which they describe as a 'Grade II Art Deco gem in Bournemouth'. At the time of writing the building is also currently used as a coworking space with plans for further development.

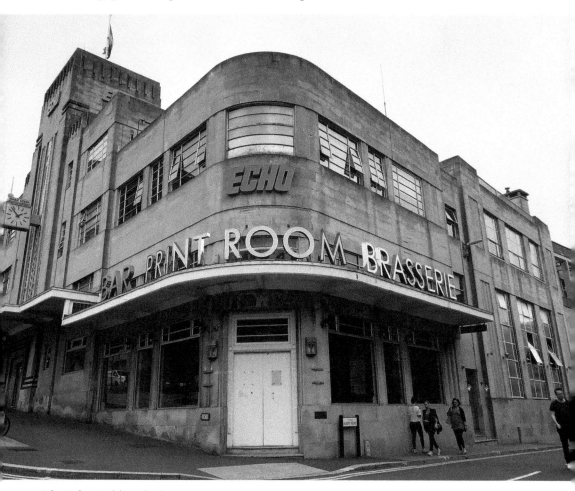

The Echo Building, built in 1932.

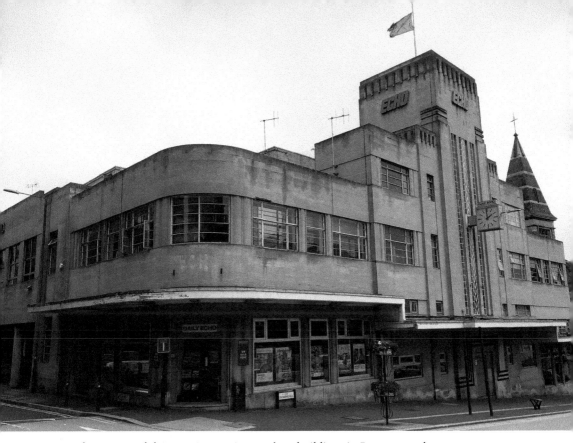

Above: One of the most impressive art deco buildings in Bournemouth.

Below: An art deco building (*c.* 1936) for the Bournemouth Gas & Water Company, later Southern Gas (1950s/60s), Green Shield Stamp Gift Shop (1970s), FADS DIY (1990s), and now Motabitz.

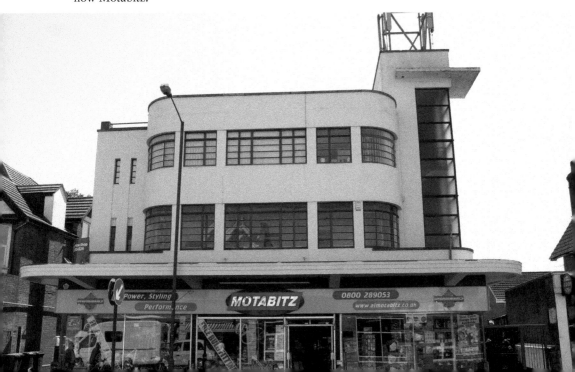

The Former Palace Court Hotel, Westover Road

Bournemouth has two relatively modern hotels: the Cumberland and the Palace Court. The Cumberland was like an Aztec temple – a stepped pyramid in true art deco style. However, the Palace Court represented an interesting departure in hotel design. It was nine storeys high and, as well as the main public rooms of the hotel, shops were provided on the ground floor. The upper storeys were designed as self-contained, serviced flats.

The Palace Court was built in 1936 in white concrete liner style, with wrap round, curved 'suntrap' balconies and the exterior was of rendered brickwork. Designed by architect Arthur John Seal, the hotel, with its palmed garden, modern lounges and its balconies laid for afternoon tea, was the epitome of 1930s sophistication. At 5 guineas per week it was certainly comparable with the Grand at Brighton, and was very exclusive. An advertisement in Bournemouth's 1939 *Guide* describes it as being 'in the heart of the colourful life of Bournemouth' and describes the hotel's extensive facilities with 'bridge organised every day by the Social Hostess … dancing to the Palace Court Hotel Band … membership of the Palace Court Club with its cocktail bar available to visitors'. Now a Premier Inn, it is a popular hotel with visitors to Bournemouth.

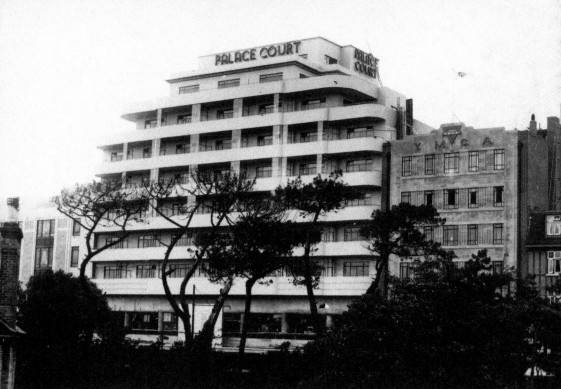

The Palace Court Hotel, built in 1936, by architect A. J. Seal.

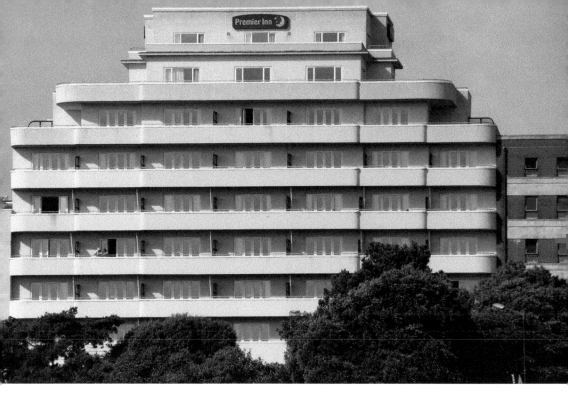

Above: The former Palace Court Hotel, now a Premier Inn.

Below: The Cumberland Hotel is now one of Europe's only freestanding art deco hotels. It was built in 1937, on the site of Fern Cliff, in the height of the art deco period. A classic-shaped building and one of Bournemouth's finest hotels.

Former Maples Furniture Store

Another art deco building in Bournemouth was built in 1937 on the site of St Peter's Church School. Maple's furniture store furnished a large proportion of the domestic properties in Bournemouth. Sir John Blundell Maple (1845–1903) was a furnishing store owner, and was possibly the most successful of all Victorian retail entrepreneurs. He achieved great wealth, became a politician, a racehorse breeder and a member of the Prince of Wales's set, and his emporium in London's Tottenham Court Road furnished everyone who was anyone in Victorian society. In 1980, Waring and Gillow joined with the cabinetmaking firm Maple & Co., to become Maple, Waring & Gillow, subsequently part of Allied Maples Group Ltd, which includes Allied Carpets. The move to turn Maples into a Waring and Gillow store was badly received locally and the store seemed to go downmarket.

On Friday 13 August 1993, two IRA firebombs went off in the basement. The furniture retailer collapsed into receivership on 2 September 1997, more than 150 years after the first store opened on London's Tottenham Court Road. Receivers Deloitte & Touche blamed high debts and poor trading for the collapse but said they hoped to sell the business as a going concern. They said there were no immediate implications for the group's 340 staff. Allders paid the receivers of Maples Stores £3.8 million for seven outlets and the rights to the brand names Waring & Gillow and Maples. The purchase took Allders total number of stores to

The former Maple store.

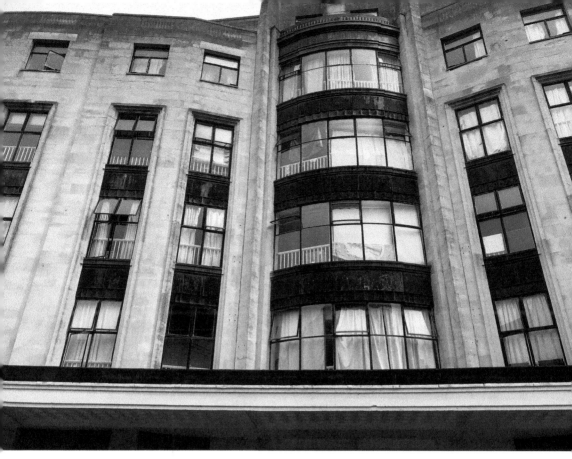

Above: Largely unoccupied, the building retains much of its art deco style.

Below: An art deco building on Old Christchurch Road, close to the former Bealesons store. Over the years it has been John Collier, Dolcis, Lilley and Skinner, Vodafone, T-Mobile, and EE.

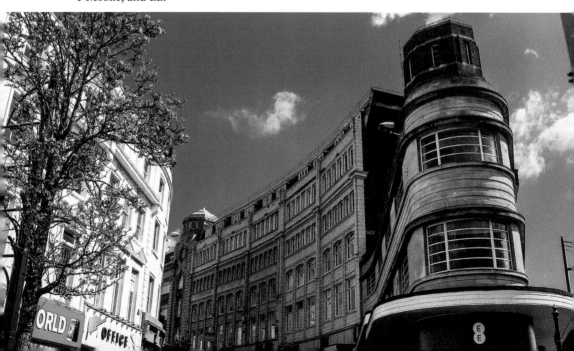

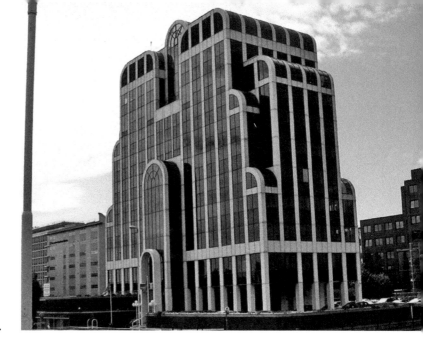

Homelife House, Nos 26–32 Oxford Road. Built as the head office for McCarthy & Stone.

thirty-seven. Bliss Bar and Chilli White opened on the ground floor and basement in 2000, and were highly regarded and visited by HRH Prince William in April 2007 while he was stationed in Blandford. However, they too were hit by the economic recession and closed in 2013. Today the building remains largely unoccupied.

44. Beales Department Store

The story of Beales began when Bournemouth was a Victorian boomtown, and it has been closely linked with the wider history of Bournemouth ever since.

Beales was founded in 1881 by John Elmes Beale, who was born in Weymouth in 1849. Beale's father was a sea captain who was lost at sea when the boy was young, and his mother arranged for John to be apprenticed to a draper in the town. After other jobs in Dorset and Manchester, John worked for the draper's John Russell in St Mary's Street, Weymouth, where he eventually became shop manager. After working there for eight years he asked for a junior partnership, which was refused, prompting him to set up in business on his own.

Agreeing not to compete with John Russell in Weymouth, J. E. Beale looked at towns such as Dorchester, Shaftesbury, Poole, Swanage and Southampton. He eventually decided on Bournemouth, which was expanding rapidly. Its population had trebled in three years and one of its most noted residents, Sir Merton Russell-Cotes, was campaigning to improve its rail service. Beale rented space in St Peter's Terrace – a new building put up on the site of two large houses. John Russell would not release him until after Christmas, so Beale had to open his shop without being there to manage it.

His shop, called Fancy Fair, opened in November with his wife Sarah in charge, although Beale himself managed a few days off from his Weymouth job to start the business. Trading was difficult at first, but the opening of the Bournemouth

West railway station in 1874 had fuelled a growth in excursion trips to the resort. Come spring 1882, Fancy Fair was stocked with buckets, spades and model boats, with prices starting at a penny.

Beale was also becoming an influential figure in town. A member of Richmond Hill Congregational Church, he became a deacon in 1896 and treasurer the next year. He became a magistrate in 1900 and then joined the town council, starting a three-year tenure as mayor in 1900.

The business was growing, undergoing a name change from Fancy Fair and Oriental House to J. E. Beale's, as the building expanded and acquired a glamorous art deco frontage in the 1930s. But the original Beales building was destroyed on 23 May 1943, when Bournemouth suffered its worst bombing of the war. Beales took a direct hit, rupturing a gas line, which started a blaze that razed the store to the ground. The store was rebuilt in the 1950s by local construction company Drewitt and continued to thrive in the post-war years.

The company expanded in the 1960s, opening a Bealesons store in Poole's new Arndale Centre in 1969 and buying shops elsewhere. Beales continued to thrive and in 1995, Beale PLC floated on the Stock Exchange and bought more stores –

The Fancy Fair became J. E. Beale. All the ornamental wrought- and cast-iron verandah was supplied and erected by Walter Macfarlane & Co., Saracen Foundry, Glasgow.

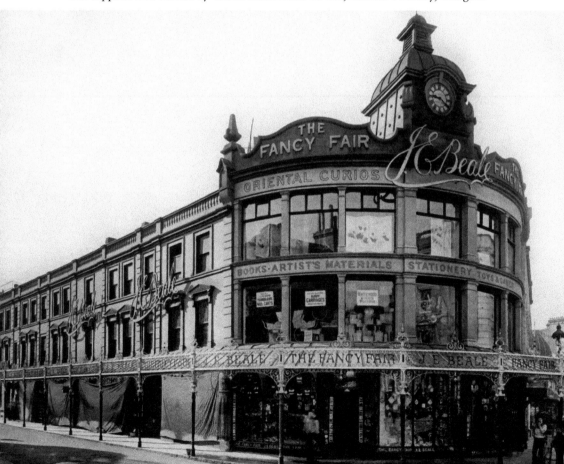

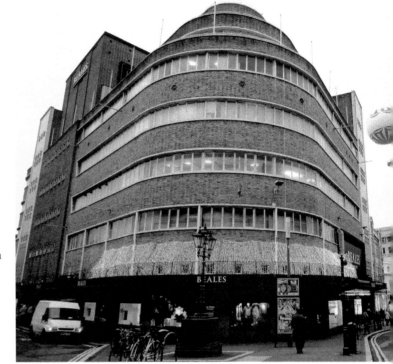

Right: Beales today – a
Bournemouth icon, under
threat in 2020 with
permanent closure.

Below: Bealesons closed in
1982. Part of their former
premises survive within
the rear façade of The
Avenue shopping centre,
which opened as The
Wessex shopping centre
in 1985.

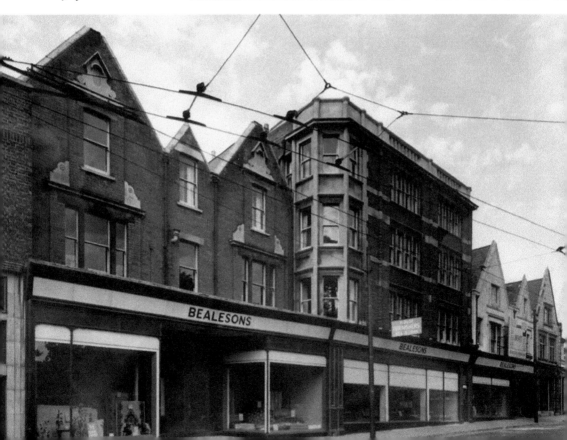

but challenging times were ahead. The company had to deal with a major drop in profits in Bournemouth and Poole with the opening of the Castlepoint shopping complex on Castle Lane in 2003, as well as the rise of internet shopping and ever more aggressive competition.

Bealesons also attracted plenty of headlines in its heyday. But in January 1982, with Britain in recession, the company announced the loss-making store would be closed. It had been competing with Beales for a dwindling number of customers and a bad tourist season had contributed to its worst ever trading year. The Bealesons store in Bournemouth eventually closed in June 1982. By 2020, Beales stores across the country are all threatened with closure as the company goes into administration. The end of an era.

45. Royal London House, Lansdowne Road

Lansdowne House was a large detached villa that was built at the junction of Christchurch Road and Holdenhurst Road, overlooking The Lansdowne, in the mid-1860s. By 1875, it was still virtually the only building that existed here.

Lansdowne House was demolished in 1891 and replaced by what was originally to be called the Palace Hotel, but which actually opened as the Metropole Hotel in 1893. On 23 May 1943, the peace was shattered when German Luftwaffe

Royal London House.

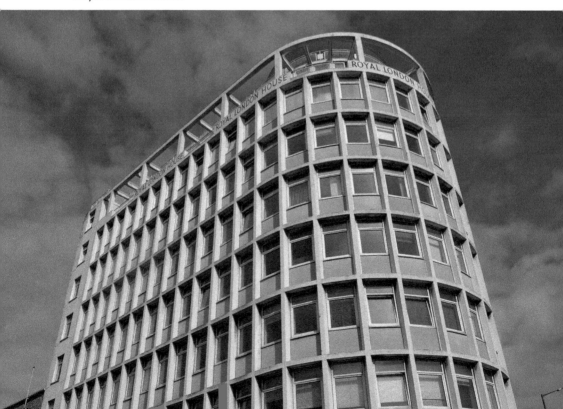

bombers flew in low over Hengistbury Head to unleash their cargo of deadly bombs across the town. Bournemouth had suffered regular air raids during the war. The first air raid came in July 1940 with the last occurring in April 1944, but this raid would prove to be one of the worst the town suffered: around twenty-five bombs were dropped, which saw twenty-two buildings destroyed, over 3,000 damaged and nearly forty of which had to be demolished. The number of deaths on that day was somewhere between 131 and 208 in total.

The most notable buildings destroyed were the Central Hotel on Richmond Hill, with the neighbouring Punshon Memorial Church severely damaged and later demolished, Beales department store on Old Christchurch Road and the Metropole Hotel. The bomb blew apart the Holdenhurst Road side of the building, with bodies reportedly thrown clear of the wreckage.

The ruins of the hotel stood overlooking The Lansdowne in the years after the war, although the Metropole Bars did reopen on the Holdenhurst Road side, until work began on the construction of Royal London House, which became the hotel's replacement in 1955.

Royal London House opened in 1958 and housed offices on its upper floors with shops at street level. Now comprising of offices used by Bournemouth University, today it is a landmark building in Bournemouth.

46. Bournemouth International Centre

Opened in 1984 at a cost of £18 million, and amid local cynicism, the Bournemouth International Centre is one of southern England's largest entertainment, events and conference venues. There are four main halls, of which the Windsor Hall can accommodate up to 4,100, making it one of the biggest indoor music arenas in the UK. The Purbeck Hall was added in 1990, costing £6 million, followed by a major £22 million refurbishment in 2004, which included the addition of a fourth hall – the Solent Hall.

As well as hosting national, annual political conferences, the venue is a major fixture on the schedules of internationally renowned musicians, bands and comedians, which has moved the town from being known for a seasonal programme of summer entertainment to an all-year round attraction and plays a major part in boosting the town's tourist economy. Very popular with locals and visitors alike and situated adjacent to the town's seafront, the imposing and impressive building is managed and operated by BH Live in partnership with BCP Council.

Prior to the building of the state-of-the-art BIC, concerts, stage shows, pantomimes & drama were staged at the Pavilion and the Winter Gardens. The latter was a much-loved venue, built in 1875 and a major feature of the town, and is still missed by locals. It was closed in 2002 and demolished in 2006. At the time of writing, redevelopment plans of the site have been submitted for approval.

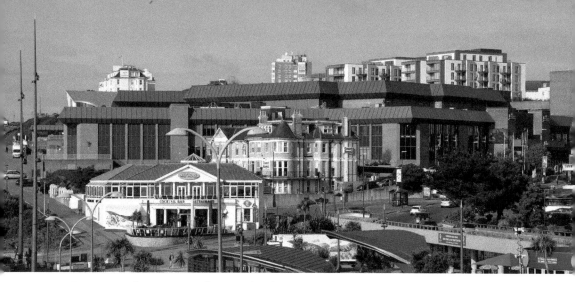

Bournemouth International Centre has been a major boost to the local economy.

47. JP Morgan with Littledown House

The striking glass structure that forms the UK Headquarters of American banking giant JP Morgan is often missed by visitors coming into the town via the A338. Built in 1984, the site was originally kept secret by the council as they tried to generate £800,000 to landscape the site to attract the bank, then called Chase

JP Morgan – today a major employer in the town.

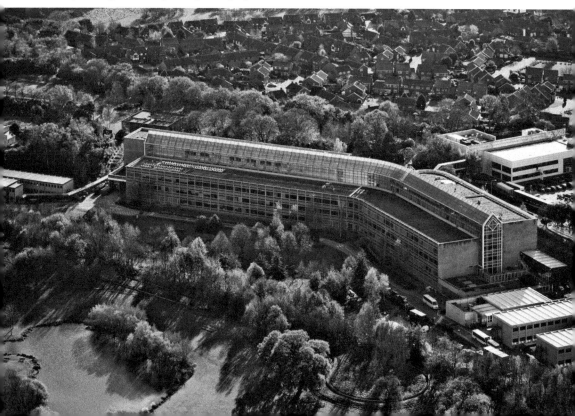

Manhattan, to relocate to the town. It was intended to develop the Wessex Fields site, which now houses the Law Courts among others, but the landowners changed their mind about selling so only one of the two pieces of land at Wessex Fields was available. At the same time, the council was to receive the last instalment of land being transferred from the Cooper Dean estate, including Littledown House and surrounding land, which was the site that was offered and accepted.

The bank now employs over 4,000 people and has raised the profile of the town globally.

The Bournemouth site is a technology and operations centre which is home to 1,000 technology specialists amongst other staff, working across ninety markets in over forty countries.

48. Former Abbey Life Building, Holdenhurst Road

One of the more modern and striking buildings today in Bournemouth is the former Abbey Life Building, which was completed and occupied in 1990, and formally opened by MP David Mellor on 7 June 1991. The building has been occupied by various tenants including Abbey Life, Unisys, Deutsche Bank, McCarthy & Stone and Capita. It has acquired a number of names locally including the 'Fairy Cake', and 'Legoland'.

The former Abbey Life building.

49. Vitality Stadium (Dean Court)

The Vitality Stadium, built in 1910, initially consisted of nothing more than a small single stand. Previously known as the Fitness First, Seward, Goldsands Stadiums and, for the majority of the football club's history, Dean Court, the football ground, was built on land given to Boscombe FC in 1910 by the Cooper-Dean family, who owned substantial land in the area.

Further stands and terraces were built in the 1930s, and Dean Court recorded its largest attendance in 1957 when 28,799 spectators showed up for an FA Cup match versus Manchester United. Plans to expand the stadium were made in the 1980s but were abandoned due to a lack of financial resources. The club has had a chequered history before enjoying its current Premier League success and sat in the 3rd and 4th Divisions of the football league for many years. Financial worries saw receivers being called in at the beginning of 1997 and the club was fifteen minutes from closing down. A trust fund was set up with the thousands of pounds raised by supporters, which took the club over.

In 2001, the stadium was entirely reconstructed with the pitch turned 90 degrees, though it initially lacked a South Stand. Over the years various temporary stands were built at the empty end, until in 2013 a permanent stand was finally completed.

Over the years, Dean Court has had various sponsor names, beginning in 2001 with the Fitness First Stadium and followed in 2011 by Seward Stadium and in 2012 by Goldsands Stadium. It announced the current naming rights deal in the summer of 2015, resulting in the name Vitality Stadium.

Following their promotion to the Premier League, the club first looked into expanding the Vitality Stadium to a potential 18,000 seats but finally decided on building a brand new stadium following a failed attempt to buy the stadium back from a property company that had previously bought it in 2005. Manager Eddie Howe, who was instrumental in the team's success and who is considered to be a local legend, was awarded the Freedom of Bournemouth in 2019.

Vitality has been one such company that has made its contribution to the local community and the built environment and none more so than on Richmond Hill. The company was created in 2004 when Discovery and Prudential launched the PruHealth brand in the UK, combining Prudential's UK distribution capability with Discovery's Vitality product that had already been launched to the market

The Vitality Stadium, home of Bournemouth AFC.

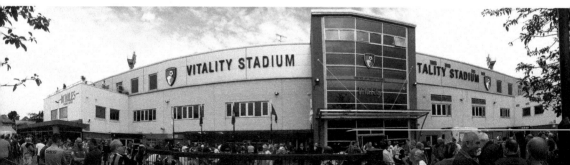

Vitality House.

in South Africa. Vitality now have a head office here in Bournemouth, employing over 500 employees. As well as naming AFC Bournemouth's home ground Vitality Stadium, Vitality are the headline sponsor of AFC Bournemouth's Community Sports Trust, as well as being the club's official wellness partner.

5c. Hilton Hotel

Hilton Hotels & Resorts opened its newest property in the UK – Hilton Bournemouth in 2015. The new hotel joined sixty-seven hotels within the Hilton portfolio across the country, including new additions at London Bankside and the Ageas Bowl, Southampton.

Classic design and quirky innovation are central to the hotel's aesthetic, with bespoke interiors and furnishings designed exclusively for Hilton Bournemouth by the former chief executive of Ted Baker, Ray Kelvin, throughout. Hilton Bournemouth was developed by a privately owned property company THAT Group, which owns the hotel and neighbouring Hampton by Hilton Bournemouth. Housed in a soaring glass structure, the 172-room property offers panoramic views to the coast and across Bournemouth.

Peter Tisdale of THAT Group was quoted as saying that 'after four years hard work we are delighted to finally open the doors of the Hilton Bournemouth, as part of our Terrace Mount development. No ordinary design, the exquisitely curated hotel incorporates refined aesthetics with a quirky edge. Sitting perfectly alongside the innovative design and technological industries of the area, it's a real head turner'.

Local craftsmanship and design influences are visible around the hotel, including specially curated items celebrating the best of British design. Artworks include a collection of local Poole Pottery, one of the largest on public display, and Colin Moore's mural of Poole Harbour, which hangs in the reception area.

Featuring eight unique meeting spaces and one of the largest ballrooms in Bournemouth, capable of hosting more than 350 guests, the hotel has collaborated with THAT Group to create a series of themed rooms capturing the pace, creativity and diversity of business. From typewriters emerging out of the walls to bowler hats hanging from the ceiling, each space offers guests a breath of fresh air.

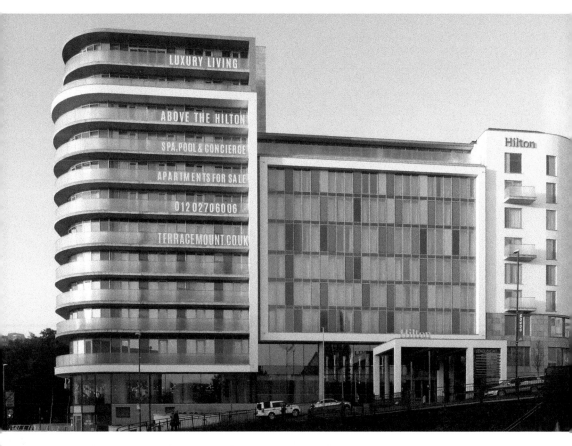

Above: The Hilton Hotel, which dominates the skyline.

Left: Innovative in design, the modern architecture of the Hilton is the epitome of the progressiveness of Bournemouth in the twenty-first century.

Bibliography

Andrews, Ian, Frank Henson, *Images of England: Bournemouth* (Tempus Publishing Ltd, 2004)

Bainbridge, John, *Francis Frith Collection: Around Bournemouth* (Francis Frith, 2000)

Bournemouth Borough Council, *The Local List* (2000)

Christopher, John, *Bournemouth Through Time* (Amberley Publishing, 2012)

Colman, Michael, *Bournemouth in Old Photographs* (Alan Sutton, 1989)

Davenport, Mary, *Bygone Bournemouth* (Phillimore, 1988)

Edwards, Elizabeth, *A History of Bournemouth: The Growth of a Victorian Town* (Phillimore, 1981)

Emery, Andrew, *A History of Bournemouth Seafront* (Tempus Publishing, 2008)

Francis Frith Collection, *Did You Know – Bournemouth – A Miscellany* (Francis Frith, 2006)

Jenkins, Simon, *England's Thousand Best Churches* (Allen Lane, 1999)

Perrin, Louise, *A Century of Bournemouth: Events, People and Places over the 20th Century* (Sutton Publishing Co. Ltd, 2002)

Perrin, Louise, Vincent May (eds), *Streets of Bournemouth* (based in part, with permission, on original research by John Soane)

Pevsner, N., D. Lloyd, *Buildings of England, Hampshire and the Isle of Wight* (1967)

'Snapshots of Bournemouth: Celebrating the Town's Bicentenary', *Daily Echo* (2010)

westbournelife.org.uk
sac-heart.org
historicengland.org.uk
bournemouthecho.co.uk
bournemouthbeatboom.wordpress.com
www.theatrestrust.org.uk/resources/theatres/show/559-thea...

Acknowledgements

Paul Rabbitts would like to thank his co-author Liz Gordon for suggesting to do this book, sharing her town with me and introducing me to so many fantastic buildings. We had fun every time. As with any such book, it is always difficult to know what to include and what to leave out and there will be those who will believe others should have been included in the list. These are based simply on those we found most fascinating at this moment in time. Thank you to all those who have donated images, and in particular Alwyn Ladell, who has captured so much of the history of Bournemouth.

Liz Gordon would like to thank her co-author Paul Rabbitts for his enthusiasm and passion for buildings, which has opened her eyes and reignited her love for her home town. She is now seeing the town in a different light and walks around with her eyes lifted so as not to miss the genuine treasures that are scattered throughout. Thank you to friends, family, colleagues and locals who have suggested buildings to include and given us anecdotes – we hope we have done you justice.

About the Authors

Paul Rabbitts is a fellow of the Royal Society of Arts and a fellow of the Landscape Institute. He is currently head of Parks, Heritage and Culture for Watford Borough Council and is also a prolific author on architecture, public parks and a noted expert on the history of the Victorian and Edwardian bandstand. He has written several books in the 'in 50 Buildings' series, including Watford, Leighton Buzzard, Luton, Salford, and Manchester.

Liz Gordon has lived in Bournemouth and surrounding areas since the 1960s and has seen the town grow and evolve into the multicultural and diverse conurbation that is today. She is managing director of Brilliant Fish PR & Marketing, specialising in working with writers and small businesses. Liz is a visiting lecturer at Bournemouth University and also festival director for the Sidmouth Literary Festival.